IMAGES
of America

CHERRY HILL
NEW JERSEY

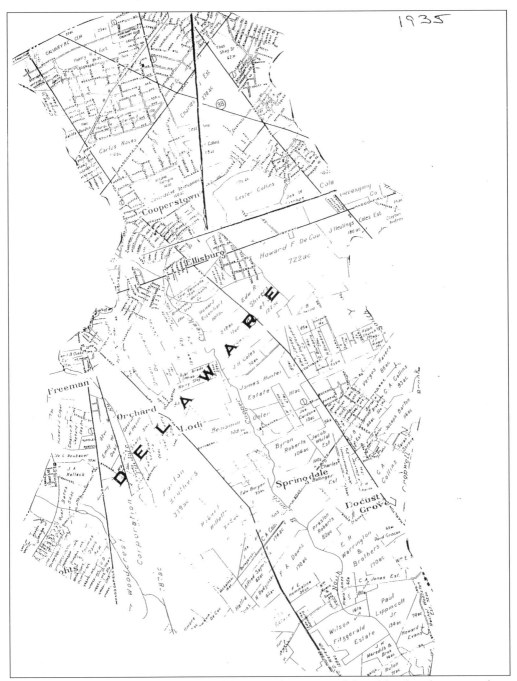

This 1935 map of Delaware Township delineates the names of the old railroad stations along the Philadelphia-Marlton-Medford line, old schoolhouses (illustrated by the circles with a line through them), and the country roads, which today are major thoroughfares that carry large volumes of traffic through the township. The Howard F. DeCou tract became the Kingston Estates development, the Woodcrest Corporation tract is where the Woodcrest development was built, and the Willowdale development comprises much of the Barton Brothers and Willits tracts. (Cherry Hill Public Library.)

IMAGES
of America

CHERRY HILL
NEW JERSEY

Mike Mathis

ARCADIA

Published by Arcadia Publishing,
an imprint of Tempus Publishing, Inc.
2 Cumberland Street
Charleston, SC 29401

Printed in Great Britain.

Library of Congress Catalog Card Number applied for.

For all general information contact Arcadia Publishing at:
Telephone 843-853-2070
Fax 843-853-0044
E-Mail edit@arcadiaimages.com

For customer service and orders:
Toll-Free 1-888-313-BOOK

Visit us on the internet at http://www.arcadiaimages.com

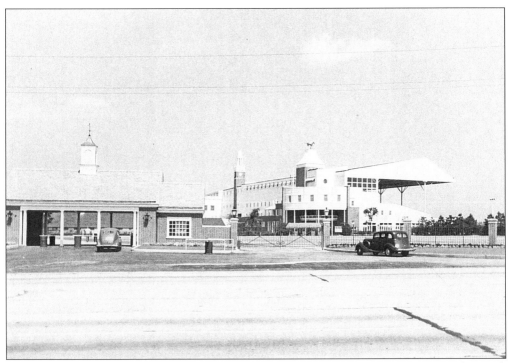

This view of the front gate of the Garden State Park Racetrack was taken just after the track opened in 1942. The track drew thousands of war-weary workers from Philadelphia and Camden who wanted to enjoy a day at the races. The gate is still standing, but the distinctive clubhouse was destroyed in 1977 by what is considered the worst fire in Cherry Hill history. (Haddonfield Public Library.)

CONTENTS

ACKNOWLEDGMENTS

The following people were extremely helpful in providing information and compiling photographs for this book: Barbara Shapiro and the staff of the Cherry Hill Public Library, Bob Georgio and Dick Harley of the Cherry Hill Fire Department, George Stein and Bill Lattiere of the Cherry Hill Police Department, Doug Rauschenberger of the Haddonfield Public Library, Kathy Tassini of the Historical Society of Haddonfield, Executive Editor Ron Martin of the *Burlington County Times*, Mayor Susan Bass Levin, Denise Weinberg of the Cherry Hill Historical Commission, Peter Hamilton and Paul W. Schopp of the Camden County Historical Society, Catherine Meng Mauer, Ron Judlicka, Elaine Dobbs, Carol Genzano, Nancy Barclay, Alice and Derben Garwood, Walt Staib, Herbert DuBois, Lisa Perrone, Eileen Stone, Clayton App, Joe Zanghi, Sherry Wolkoff, Frances Gaines Cryer, Lou Toth, Rachelle Omenson, The Rouse Corporation, and Garden State Park.

I also want to thank my wife, Beverly, for her assistance, patience, and support during this project.

INTRODUCTION

Native Americans inhabited the area before Western Europeans, particularly members of the Society of Friends, settled and farmed the land along the banks of the Cooper River and the Pennsauken Creek in the 1600s. Names of these farms appear today as names of housing developments; some of the farms were called Cherry Hill, Brookfield, Woodland, Cedar Grove, Locust Hill, Locust Grove, Woodland, Pleasant Valley, and Deer Park.

Before 1961, it was impossible to find Cherry Hill on a map, because it did not exist—the township was known first as Waterford Township when it was one of the original townships of old Gloucester County in 1695, and then Delaware Township when Camden County was established in 1844. The state legislature approved the creation of Delaware Township on February 28, 1844, and the first town meeting was held on March 13, 1844. The community remained largely agrarian with a several mills and villages such as Colestown, Batesville, and Ellisburg, which served as the seat of government.

Life remained peaceful in Delaware Township until the 1920s, when a real estate boom led to the development of neighborhoods such as Colwick, Erlton, Barlow, Hinchman, and Locustwood. However, the good times did not last. In 1933, the state took financial control after the township had trouble meeting its financial obligations.

By 1942, the township's fortunes began to turn around. The opening of the Garden State Park Racetrack in 1942 by Vineland businessman Eugene Mori ushered in an era in which Delaware Township would become the entertainment and shopping mecca of the East Coast. The Cherry Hill Inn, the Rickshaw Inn, the Hawaiian Cottage, the Latin Casino, and Cinelli's Country House were among the many nightspots that thrived in the 1950s and 1960s. In 1961, the Cherry Hill Mall opened as one of the first enclosed malls in the nation.

The exodus from the cities to the suburbs was no more apparent than in Delaware Township. New homes in subdivisions such as Kingston Estates, Greenhaven, Cherry Hill Estates, Windsor Park, and Barclay Farms soon covered much of the farmland on the west side of town. People moved from Philadelphia and Camden, seeking larger properties and safer surroundings. The population exploded from 10,358 in 1950 to 64,395 by 1970.

The growth and the fact that Delaware Township was served by five different post offices prompted officials and residents to lobby the U.S. Postal Service to establish a separate post office. The name "Delaware" could not appear in the name because another municipality in northern New Jersey already had a post office by that name. A contest was held to rename the township. The overwhelming choice, Cherry Hill, was the name of Abraham Browning's farm, which occupied the property where the Cherry Hill Inn was built. Voters adopted the new name in November 1961.

Cherry Hill remains a thriving community with an abundance of housing styles, shopping, and recreational activities.

BIBLIOGRAPHY

Dorwart, Jeffery M. and Philip English Mackey. *Camden County, New Jersey: A Narrative History 1616–1976*. Camden County Cultural and Heritage Commission, 1976.

Prowell, George R. *History of Camden County, New Jersey*. Philadelphia: L.J. Richards and Co., 1886.

Cherry Hill Historical Commission. *Auto Tour of Historic Sites in the Township of Cherry Hill*. Blackwood, NJ: Crowley and Associates.

Remington and Vernick Engineers. *Township of Cherry Hill Historic Resource Survey*. Haddonfield, NJ, June 1998.

One
EARLY BEGINNINGS

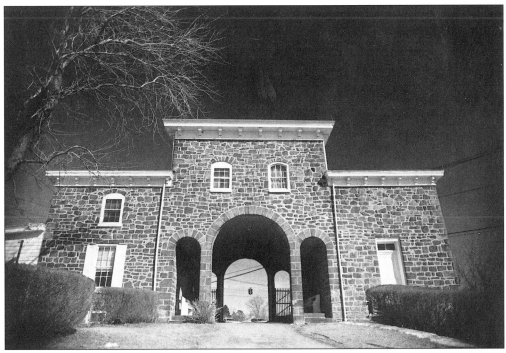

The Colestown Cemetery represents the only lasting remnant of Colestown, a small village founded in 1676 on the south branch of the Pennsauken Creek. The village, which contained two stores, a blacksmith shop, and several dwellings, grew with the popularity of the Fountain Hotel resort in the 1800s. The stone gatehouse was built in 1858, although the earliest burial in the cemetery was recorded in 1746. The gatehouse has been listed on the National Register of Historic Places since 1975. (*Burlington County Times.*)

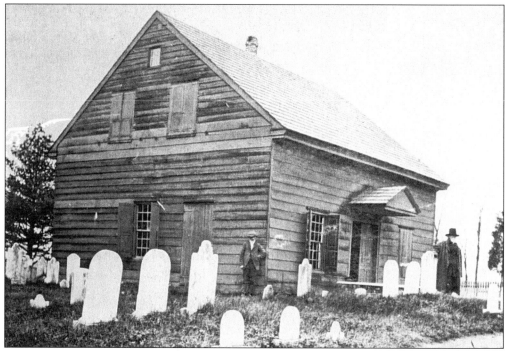

St. Mary's Episcopal Church was built inside the grounds of Colestown Cemetery in 1751. It was destroyed by fire in 1899. (Historical Society of Haddonfield.)

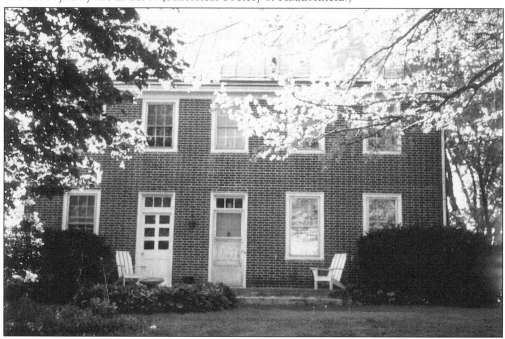

The Inskeep House on Brick Road was built by John Inskeep, a veteran of the Revolutionary War who served as mayor of Philadelphia in 1800 and from 1804 to 1807. He was also president of the Insurance Company of North America. Inskeep, who was born in 1757, died in 1834. (Cherry Hill Public Library.)

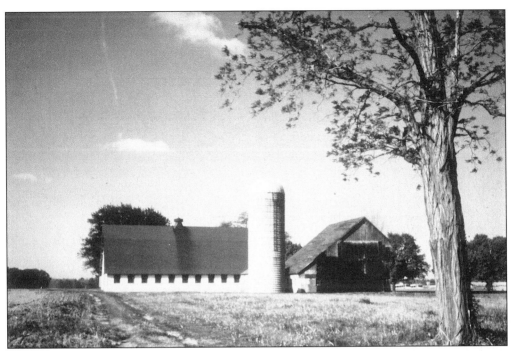

This barn stood on the Inskeep property. (Cherry Hill Public Library.)

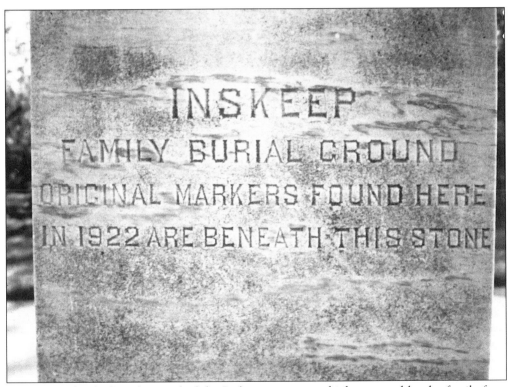

INSKEEP
FAMILY BURIAL GROUND
ORIGINAL MARKERS FOUND HERE
IN 1922 ARE BENEATH THIS STONE

A stone marks the burial ground of the Inskeep property, which was used by the family from 1729 to c. 1840. (Cherry Hill Public Library.)

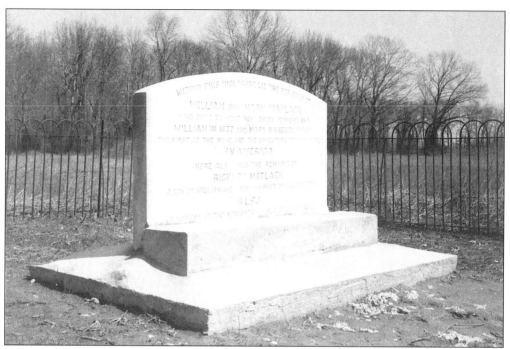

The Matlack gravesite on Balsam Road in the Woodcrest development marks the burial site of one of West Jersey's first settlers, William Matlack, and some of his relatives and servants. Matlack, a carpenter by trade, came to the area from England in 1677. The grave is located on his original homestead. (Cherry Hill Public Library.)

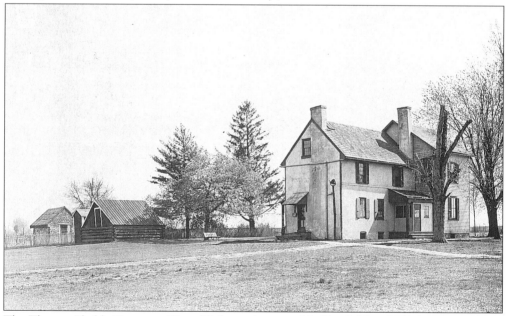

The Thomas Shakle House on Kings Highway, between Haddonfield and Ellisburg, served as a meetinghouse for Quakers between 1695 and 1721, when the Haddonfield monthly meeting was established. Members met alternately between this house and the Newton Friends meeting in what is today West Collingswood. (Historical Society of Haddonfield.)

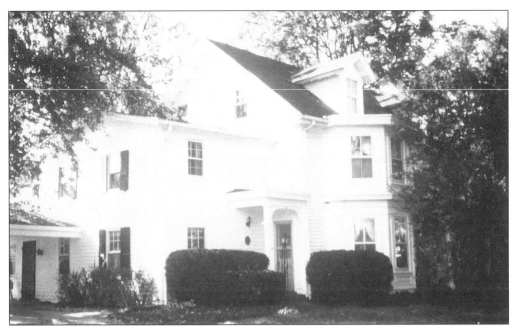

The Willits/Caleb Lippincott House on Robin Lake Drive in the Willowdale section of Cherry Hill dates to the early 1700s, and as of the early 1990s had been inhabited by members of the same family for nine generations. (Cherry Hill Public Library.)

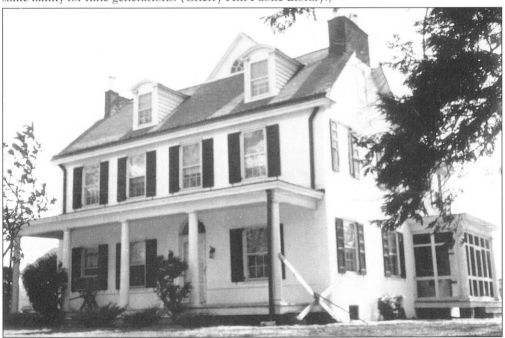

The oldest portion of the Croft Farm on Borton's Mill Road was built c. 1779. The house was a stop on the Underground Railroad, where owner Thomas Evans sheltered slaves shuttled by wagon from Woodbury, then sent to Mount Holly the next night. The property, which consists of a plantation house, smokehouse, springhouse, icehouse, corn crib, and pole and animal barns, is now owned by the township as a performing arts center. (Cherry Hill Public Library.)

The barn at the Croft Farm is shown here on April 4, 1950. (Haddonfield Public Library.)

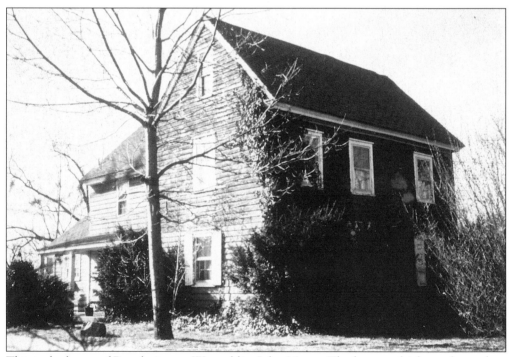

This is the house of Revolutionary War soldier John Mapes. The house, which was located on Burnt Mill Road across from the Downs Farm development, has been demolished. The community mounted opposition in the 1970s when a developer proposed a $12 million, 354-unit high-rise development. (Cherry Hill Public Library.)

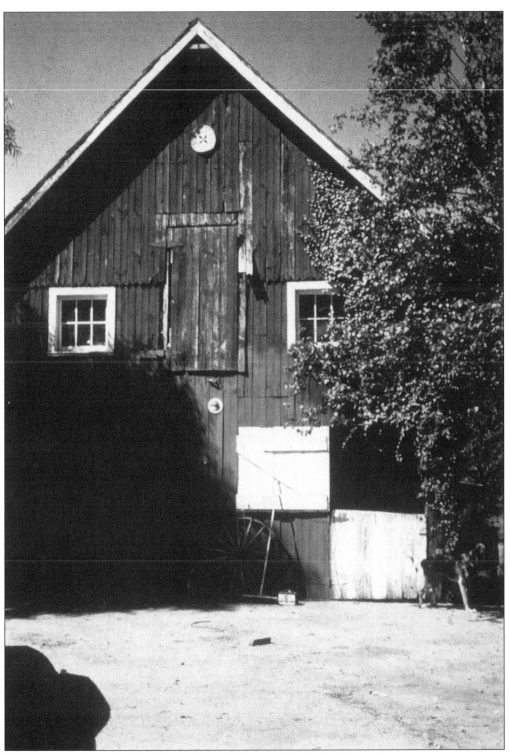

This barn stood on the John Mapes Farm. (Cherry Hill Public Library.)

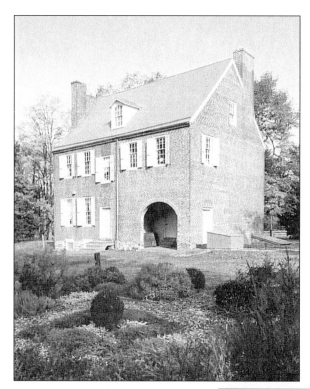

The Barclay Farmstead, situated on Barclay Lane in the Barclay Farms section of Cherry Hill, dates to the early 1800s, and was built by Joseph Thorn, who purchased the property in 1816. The 32-acre site, which features a three-story brick farmhouse, an operating forge, and a springhouse, was acquired by the township in 1974. It is listed on the state and National Register of Historic Places. The Barclay family last occupied the house in 1929. (Cherry Hill Public Library.)

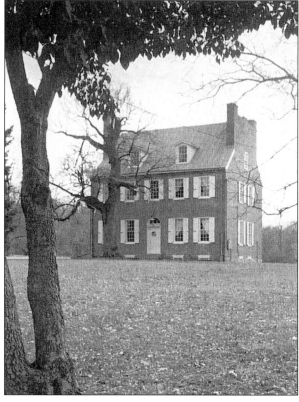

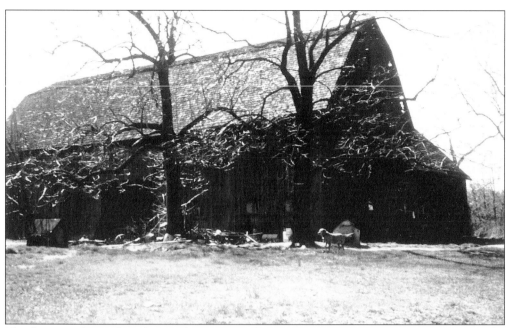

This barn was located on the Barclay Farmstead property. (Cherry Hill Public Library.)

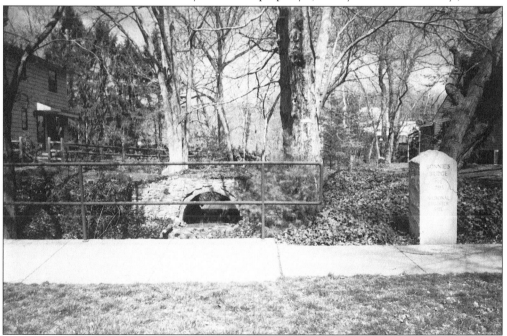

Bonnie's Bridge on Wayland Road in the Barclay Farms section of Cherry Hill is the last surviving stone arch bridge in Camden County. Its significance dates to the Revolutionary War, when it is believed more than 15,000 members of the British Army used the span when they fled Philadelphia in June 1778. Many of the troops marched to Freehold, where General George Washington engaged them in the Battle of Monmouth. The bridge is named for Bonnie Cocchiareley, whose efforts to preserve it led to its inclusion on the National Register of Historic Places in 1981. (Lisa Perrone and Eileen Stone.)

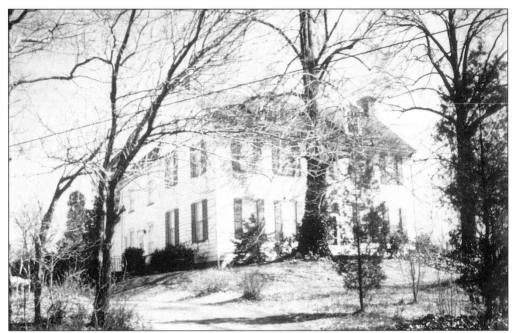

The oldest section of the John Kay House on Munn Lane was built *c.* 1730 by Kay, a wealthy landowner and mill operator. He was elected for several terms to the West Jersey Assembly and also served in the Assembly of the Royal Colony of New Jersey, where he served as speaker for four years. He was also appointed a justice for Gloucester County. (Cherry Hill Public Library.)

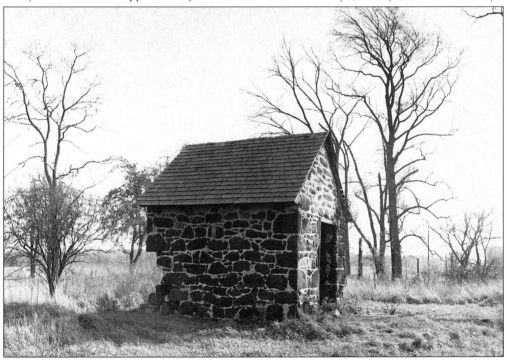

This old smokehouse stood on the grounds of the Burroughs Farm, which was located on Church Road near Lenape Road. (Cherry Hill Historical Commission.)

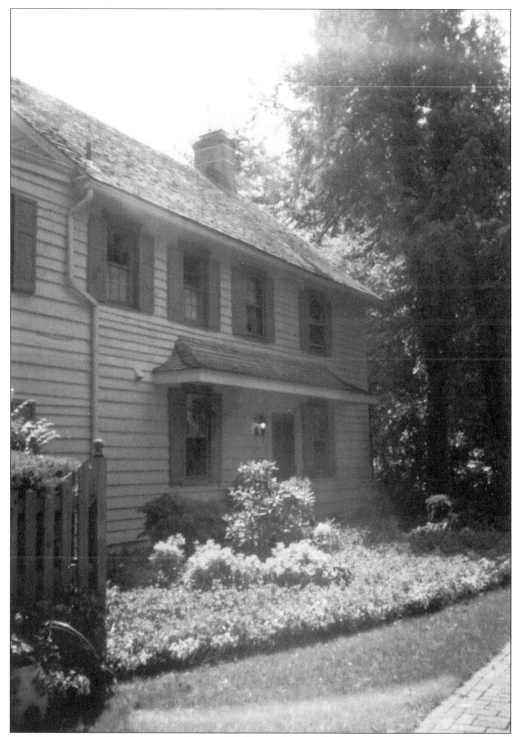

The Springhouse Farmhouse on Springdale Road dates to before the Revolutionary War and was believed to have been built by a member of the Wills family. A 10-foot-deep, hand-dug well in the basement served the house until 1990. (Cherry Hill Public Library.)

The 1743 house on Old Cuthbert Road is on the state and National Register of Historic Places. It is believed that one of the owners, local sheriff John Ellis, used the cellar as a jail in the 1800s. (Cherry Hill Public Library.)

The Worthington House, located on Haddonfield-Berlin Road in the Woodcrest section of the township, was built c. 1790 with alterations made c. 1890. The Federal-Greek Revival house served as the sales office for the Woodcrest Development Co. when construction of the Woodcrest development began in the 1950s. (Cherry Hill Public Library.)

The Coles House on Kings Highway was built in the early 1800s by the descendants of Samuel Coles, one of the original British proprietors who acquired one share of West Jersey in 1676. The Coles family farmed property that is now part of Kingston Estates. The Unitarian Universalist Church bought the house in 1960. (Cherry Hill Public Library.)

The Coffin Farmhouse at Evesham and Haddonfield-Berlin Roads was the home of Major Edward Coffin, a distinguished Civil War veteran and agriculturist, whose family was involved in glass manufacturing. It is believed that the house was visited by poet Walt Whitman when he lived in Camden. The Coffin family occupied the home from the time of the Civil War until the 1970s. A Quaker schoolhouse existed on the Voorhees side of Evesham Road in the early 19th century. (Cherry Hill Public Library.)

This is the site on Crooked Lane where a stagecoach bridge leading to the village of Colestown collapsed in 1914. The lane, which fell into disuse after the collapse, led from Haddonfield Road to Fellowship Road. (*Burlington County Times.*)

These homes are located in Batesvill along Haddonfield-Berlin Road. Batesville, which featured a blacksmith shop, a wheelwright, and other stores, developed around the busy junction of Haddonfield-Berlin and Kresson Roads. It was named after William Bates, an early settler and major property owner and developer in the 1800s. (Cherry Hill Public Library.)

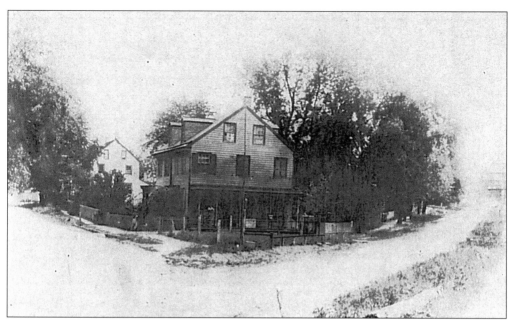

Bates' home was transformed by his grandson into the Blazing Rag Tavern, which operated from 1850 to 1900. Among the events hosted at the Blazing Rag was cockfighting, an event that attracted spectators from as far away as Philadelphia. (Historical Society of Haddonfield.)

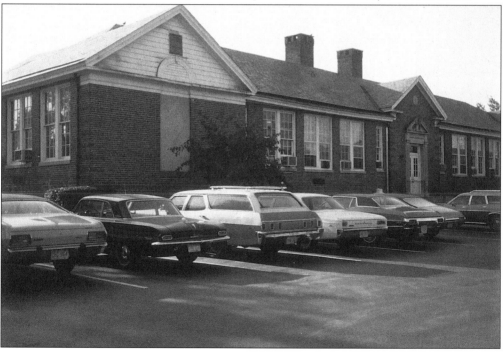

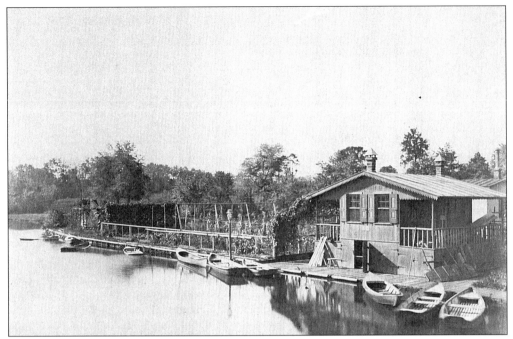

Boats sit idle in the water on Evans Pond in Batesville, October 17, 1884. Many of the old homes are now gone, and Evans Pond is part of the Camden County Park System. (Historical Society of Haddonfield.)

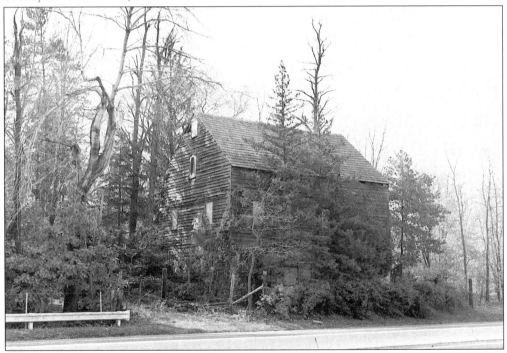

The Leconey Gristmill was built on Route 38 near Church Road by Reuben Roberts in 1838 and was sold to Richard Leconey a few years later. It was the site of two murders, Leconey's niece in 1889, and an unidentified victim in 1891. (Cherry Hill Historical Commission.)

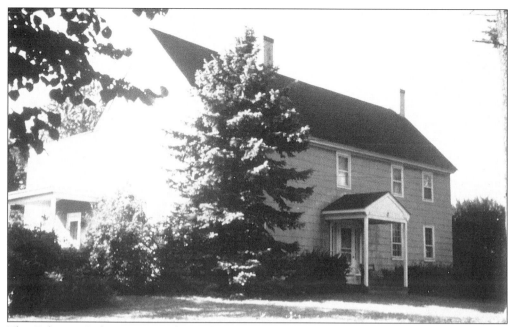

The Riley or Roberts House, located on Crooked Lane, was built *c.* 1765. The colonial, Georgian-style dwelling was part of the original village of Colestown and was the home of the Roberts family, which operated a gristmill in the township in the early 19th century. They were prominent community leaders. (Cherry Hill Public Library.)

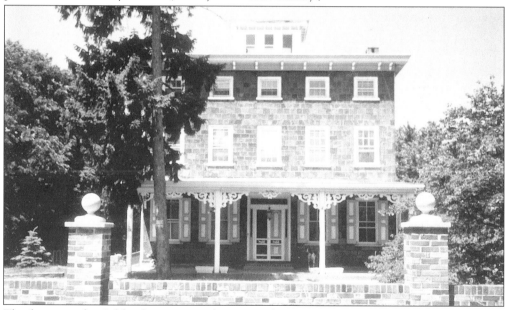

This house in the Ashland section was known as the Henszey Mansion, and was the suburban home of a wealthy Philadelphia family. The three-story structure, considered one of the finest examples of suburban brownstone Italianate villas erected in Camden County, was built *c.* 1870 at what is today Ashland and Railroad Avenues. It served as an advertisement for the suburban development that occurred in the area in the late 19th and early 20th centuries. (Cherry Hill Public Library.)

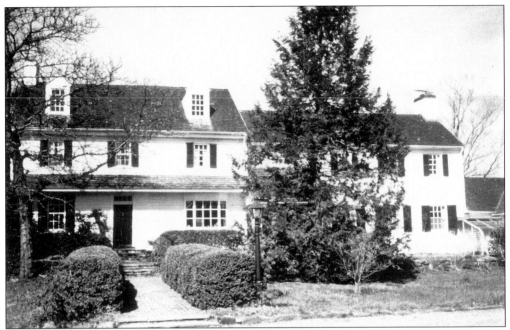

The Archer House, a Georgian-style farmhouse on Munn Lane in the Hunt Tract off Brace Road, was built c. 1790 and is typical of the wood-frame houses built in the Northeast in the late 1700s. The lack of ornamentation and fancy decoration on the house may reflect Quaker simplicity. (Cherry Hill Public Library.)

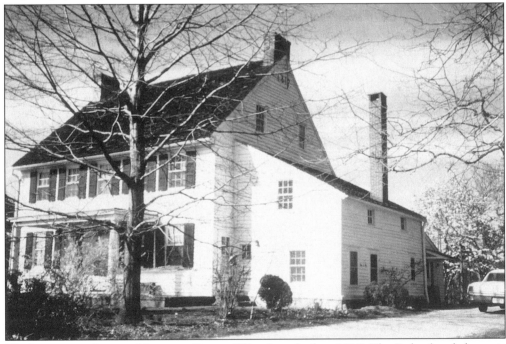

The Lippincott-Griscom House on Cropwell Road was built c. 1812. The Federal-style home is considered a fine example of local farmhouse architecture. It is believed that at one time slaves were hidden in the attic. (Cherry Hill Public Library.)

Two
COUNTRY CROSSROADS

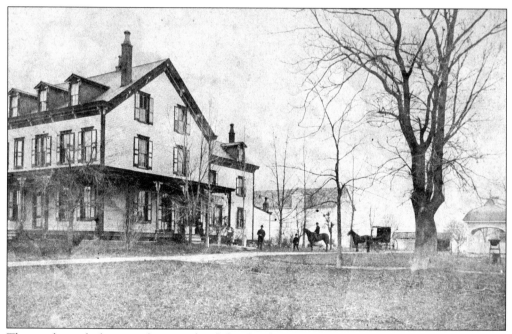

This is the only known photograph of the farmhouse on Abraham Browning's Cherry Hill Farm, from which Cherry Hill derived its name. Browning constructed the farmhouse c. 1875. It later became the site of the Cherry Hill Inn and the Loews movie theater complex. The farm may have derived its name from a cherry orchard that stood on the property. Browning, a powerful Camden City political figure, operated a ferry landing on Market Street, and was instrumental in securing Camden as the county seat in 1848 after a protracted battle with those who favored Long-A-Coming (now known as Berlin Borough). (Cherry Hill Historical Commission.)

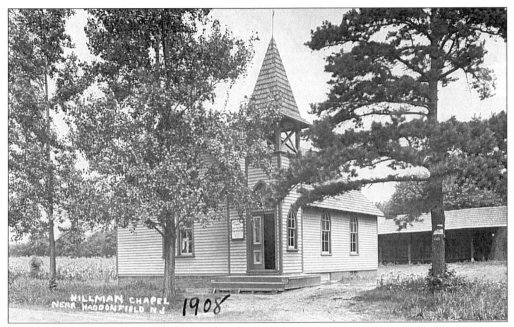

The Hillman Baptist Church on Kresson Road dates to 1891 and was a mission of the First Baptist Church of Haddonfield. It primarily served an integrated congregation of farmers and workers. The church has been transformed into a private residence. (Cherry Hill Historical Commission.)

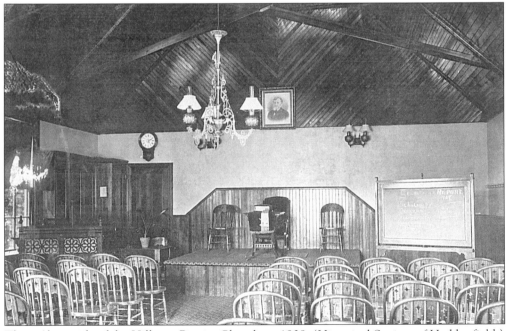

This is the inside of the Hillman Baptist Church, c. 1908. (Historical Society of Haddonfield.)

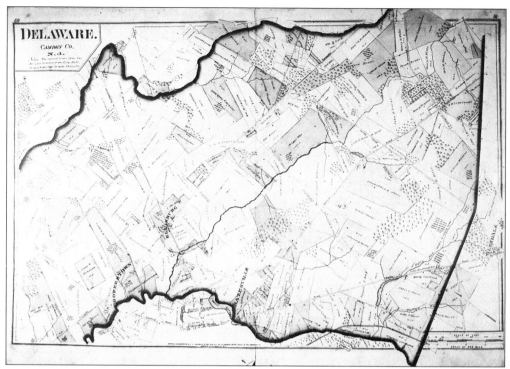

A map of Delaware Township from 1877 illustrates the farms that enveloped the landscape and some of the roads that exist today, such as Marlton Pike, Kings Highway, Milford (now Kresson) Road, Mill (now Burnt Mill) Road, and Haddonfield-Berlin Road. Much of the eastern part of this map did not change until the 1960s. (Cherry Hill Historical Commission.)

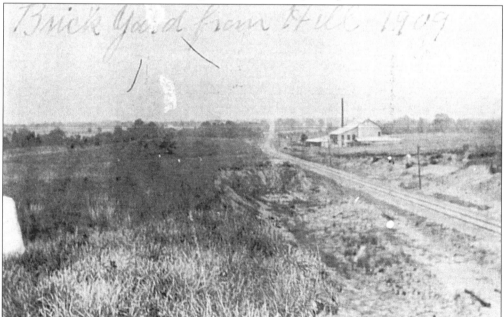

This is a 1909 view of the old brickyard that stood along Marlkress Road. Marlkress Road used to be known as Brickyard Road. (Historical Society of Haddonfield.)

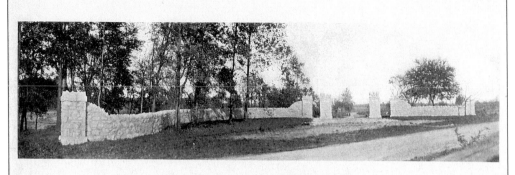

Locust Wood

CAMDEN COUNTY'S BEAUTIFUL NEW BURIAL PARK

LAWN PLAN
PERPETUAL CARE
AN IDEAL PLACE

LOCATED ON THE MARLTON PIKE, FIVE MILES FROM
ALL FERRIES ENTERING CAMDEN—REACHED
BY TRAIN; OR HADDONFIELD TROLLEY
FROM WESTMONT

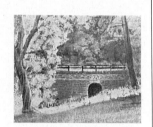

Some of the Important Features
of Locust Wood Cemetery:

IT IS THE MOST BEAUTIFULLY SITUATED OF ALL NEW JERSEY CEMETERIES

ITS ROADS ARE OF THE VERY BEST

IT HAS A COMFORTABLE OFFICE AND WAITING ROOM

IT IS STRICTLY A "MODERN CEMETERY"

Lots can be purchased on time and are cared for perpetually, free of all expense to lot=holders

FULL PARTICULARS, MAIN OFFICE

LOCUST WOOD CEMETERY CO.

423
MARKET ST.
CAMDEN
N. J.

This advertisement for Locustwood Cemetery on Marlton Pike appeared in local newspapers and city directories when the cemetery opened in 1904. The ads boasted of the easy access to the cemetery from Camden and its amenities. (Alice and Derben Garwood.)

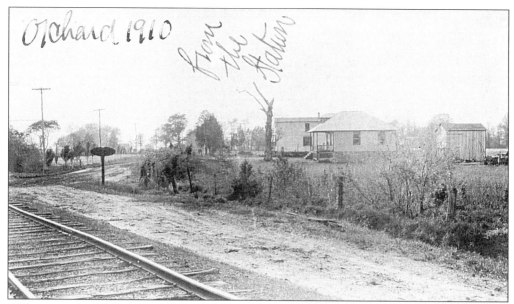

This scene of rural Delaware Township was taken in 1909 from the platform of the Orchard Railroad Station. The station stood near Kresson Road and Interstate 295. (Historical Society of Haddonfield.)

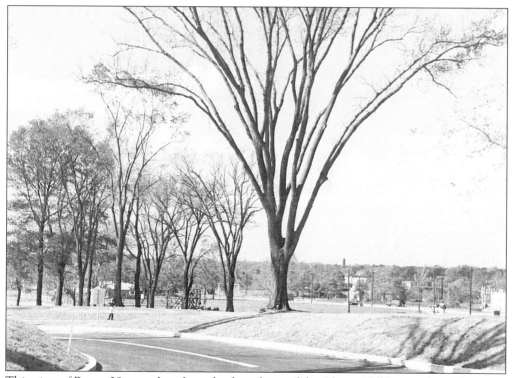

This view of Route 38 was taken from the front lawn of the Cherry Hill Inn in the early 1950s. The old Esso service station and the homes in the distance have long since been demolished and the properties developed for commercial use. (Haddonfield Public Library.)

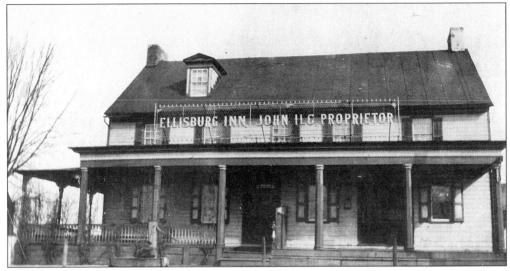

John Ilg's Ellisburg Inn served as a stopover for the stagecoach until 1881, when the railroad between Philadelphia and Medford began operation. The inn was demolished in 1938 when the Ellisburg Circle was constructed. (Cherry Hill Historical Commission.)

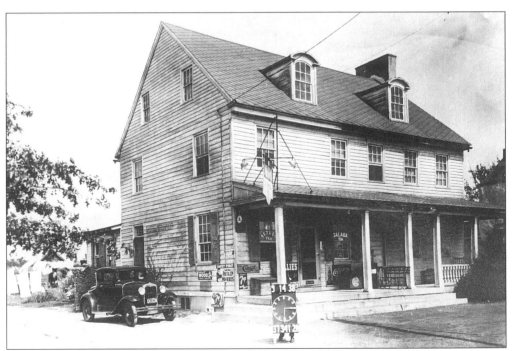

The Ellisburg General Store, originally owned by Isaac Ellis, was reputed to be more than 100 years old in 1917. Located across from the Ellisburg Inn, it was also razed for construction of the Ellisburg Circle. (Cherry Hill Historical Commission.)

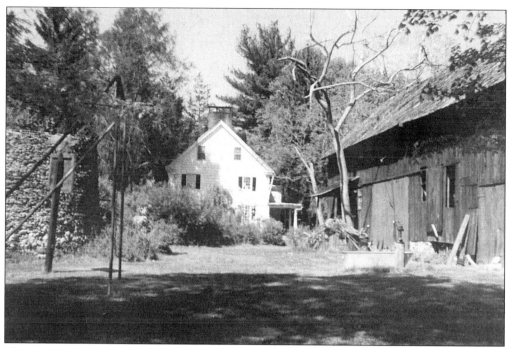

The Roberts Farm on Route 38 is now the site of the Woodland Falls Corporate Center. (Clayton App.)

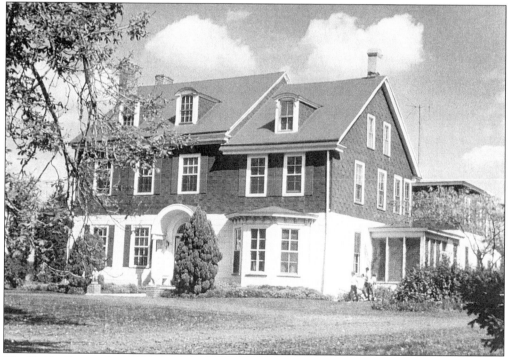

The Dobbs Farm, which stretched for acres along Haddonfield-Berlin Road, is now occupied by the headquarters of Garden State Cable TV. Dobbs Lane, the street leading to the cable television building, is named for the family. (Elaine Dobbs.)

Season's

Short Hills Farm on Evesham Road, built by John Wilkins in 1860, was once the home of Senator David Baird and was a well-known horse training facility before homes were built on

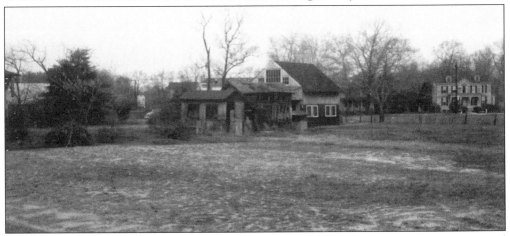

These photographs show the Batesville area as it appeared in the 1930s. The area has retained some of its rural characteristics despite the fact that thousands of cars travel on Kresson and

Greetings

the property in the late 1990s. Baird was a powerful Camden County Republican leader whose power spanned from 1880 through 1933. (Cherry Hill Historical Commission.)

Haddonfield-Berlin Roads daily. The house in the distance still stands on Kresson Road. (Cherry Hill Historical Commission.)

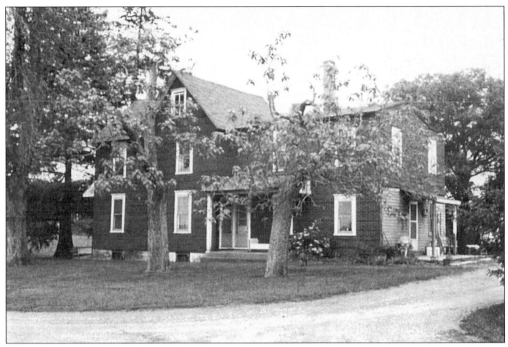

These photographs of the Garwood Farm on Springdale Road were taken *c.* 1960. The site is now occupied by the Bethel Baptist Church and is adjacent to Springdale Farm, the township's last "working farm." (Alice and Derben Garwood.)

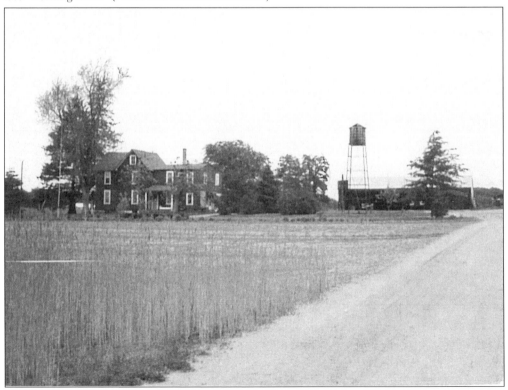

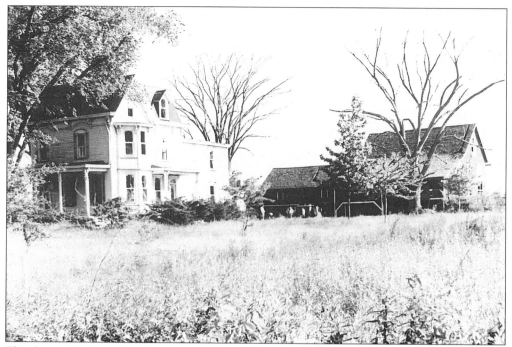

This farm, which stood on land now occupied by a Pathmark supermarket on Church Road, was destroyed by fire on January 25, 1963. (Dick Harley.)

The township's first police station was located on land now occupied by the parking lot of St. Andrew's United Methodist Church on Route 70 near Kings Highway. (George Stein.)

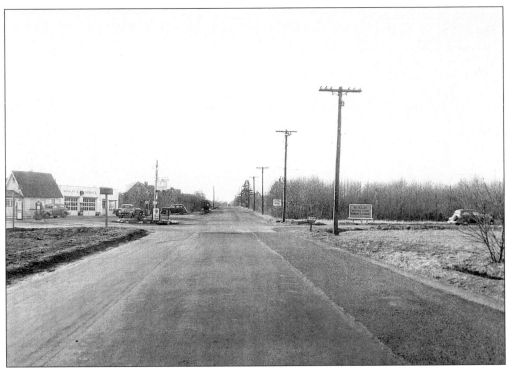

The intersection of Haddonfield and Church Roads is shown here on April 20, 1950. (George Stein.)

This is the intersection of Haddonfield Road and Maple Avenue looking toward Pennsauken in 1950. (George Stein.)

Haddonfield Road is shown here in a photograph taken while looking toward Church Road in the 1950s. (Bill Lattiere.)

This is the intersection of Haddonfield-Berlin Road at Browning Lane and Burnt Mill Road in the early 1950s. The house on the left is the site of Vito's Pizza and the ground on right is occupied by homes that comprised the original section of the Woodcrest development. (Bob Georgio.)

This rural view of Kresson Road was taken on December 23, 1951. The Hillman Baptist Church is at the left. (Haddonfield Public Library.)

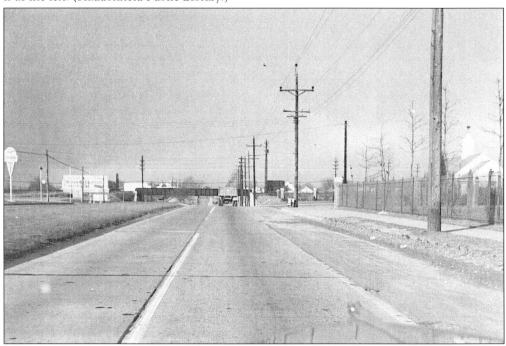

Marlton Pike is shown here in front of the Garden State Park Racetrack on December 13, 1952. The Marlton Pike, formerly known as the Camden-Marlton Turnpike, was laid out in 1795 to intersect Haddonfield-Moorestown Road (now known as Kings Highway). (Haddonfield Public Library.)

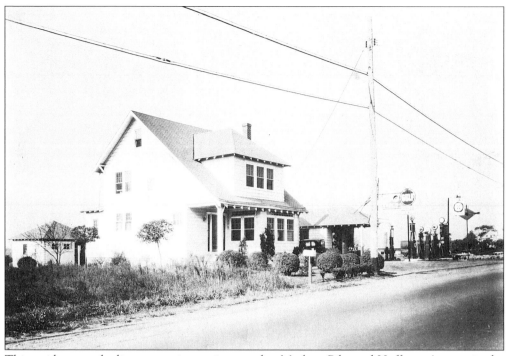

This residence and adjacent service station stood at Marlton Pike and Hoffman Avenue in the 1930s. (Evelyn White.)

Springdale Road was a dirt lane when this photograph was taken in the 1920s. (Alice and Derben Garwood.)

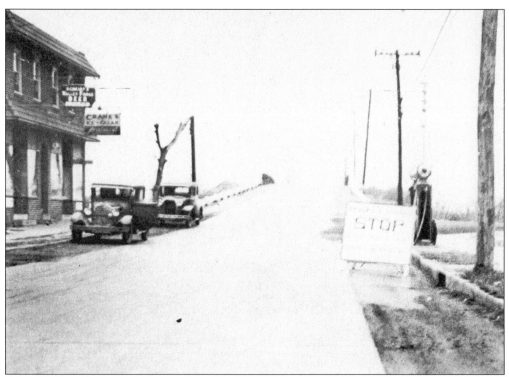

Lena's Cafe has been a landmark at the foot of the railroad bridge along Chapel Avenue for decades. (Cherry Hill Historical Commission.)

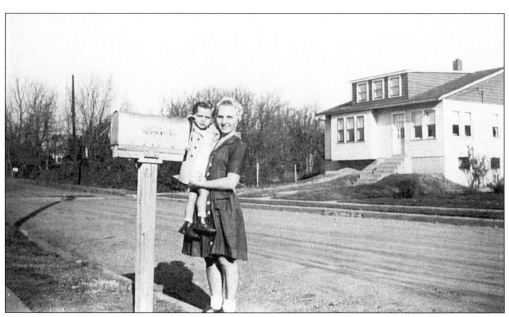

A woman and her child pose on Evergreen Avenue in the Woodland section of the township in 1947. (Carol Genzano.)

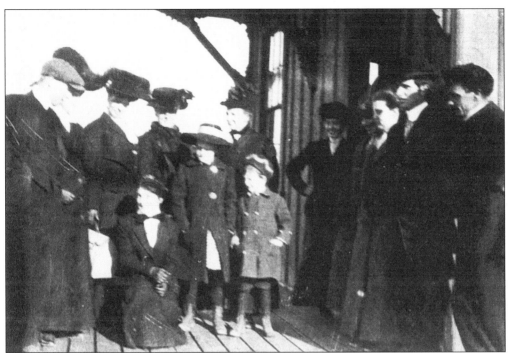

People gather on the platform at Springdale Station, one of several stops along the Philadelphia-Marlton-Medford Railroad, which ran through Delaware Township from *c*. 1880 until 1927. Other stops included Freeman Station near Brace and Haddonfield-Berlin Roads, Orchard Station near Kresson and Covered Bridge Roads, Springdale Station on Springdale Road, Locust Grove Station on Marlton Pike near what is the Old Orchard development, and Cropwell Station on the Evesham border. (Alice and Derben Garwood.)

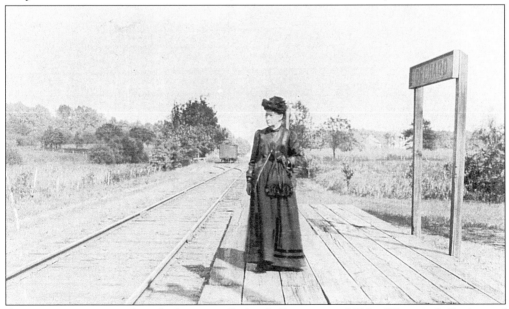

A woman waits on the platform at Orchard Station in 1909. (Historical Society of Haddonfield.)

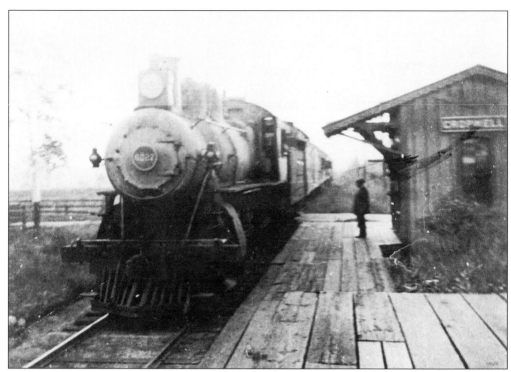

A train pulls into Cropwell Station, which was located in the area of Marlton Pike and Cropwell Road in Evesham just over the Delaware Township line. (Cherry Hill Historical Commission.)

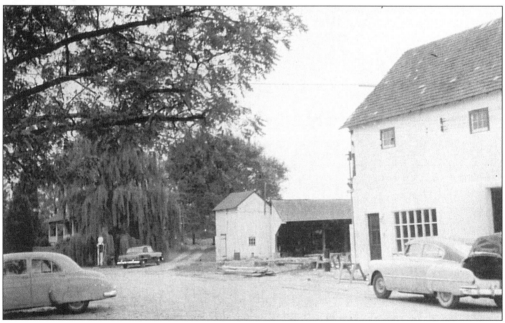

These photographs of the Barton Farm on Kresson Road were taken in the 1950s. The farm was located near what is now Heartwood Drive, and included a packinghouse for fresh produce. (Nancy Barclay.)

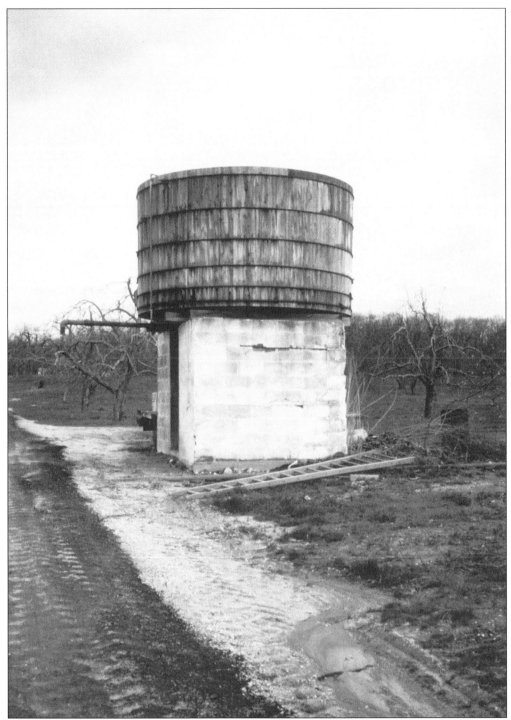

This water tower stood on the DeCou Farm, which encompassed hundreds of acres straddling Kings Highway in the area of Chapel Avenue. Much of the farm, which had a market at Kings Highway and Chapel Avenue that featured fresh produce and a dairy bar, was sold and part of the land became the Kingston Estates development. (Cherry Hill Public Library.)

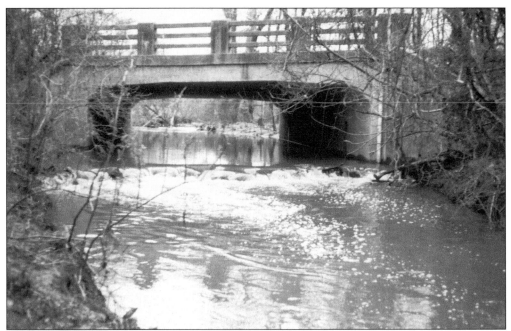

This small bridge over the north branch of the Cooper River on Springdale Road served a predominantly rural population for decades. It was replaced in 1999 when Springdale Road was widened from two to five lanes to accommodate the development in the area. (Cherry Hill Public Library.)

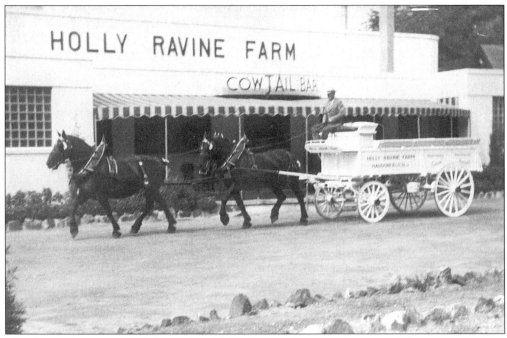

This horse-drawn wagon belonged to Holly Ravine Farm, and was used for events such as parades and transporting Santa Claus to Haddonfield during the Christmas season. (Eva Gilmour.)

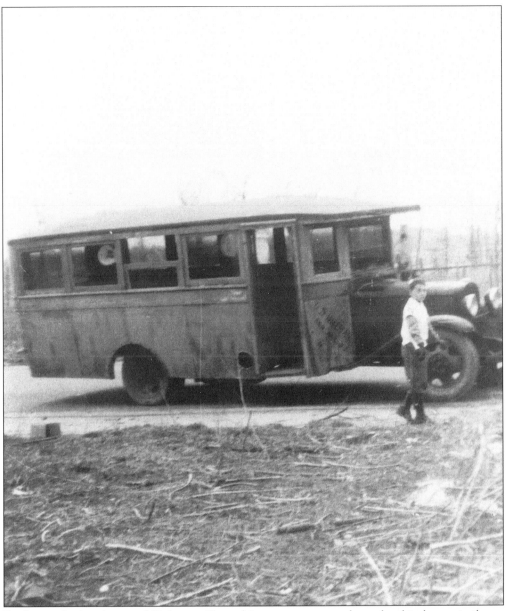

Students who lived in rural Delaware Township were transported to school in buses similar to this one. The bus belongs to Hillman, which operated a bus company based in Lindenwold in the 1990s. (Cherry Hill Public Library.)

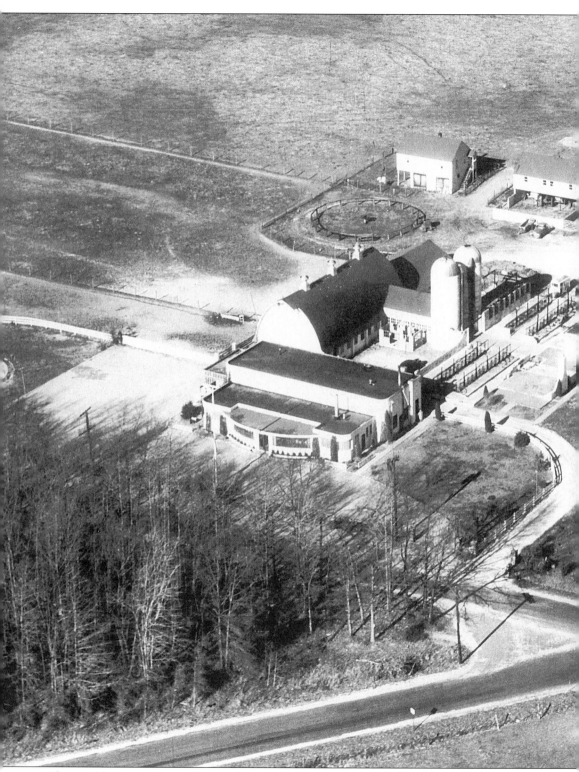

This aerial view of Holly Ravine Farm was taken in March 1953. The intersection at the

bottom is Springdale and Evesham Roads. (Eva Gilmour.)

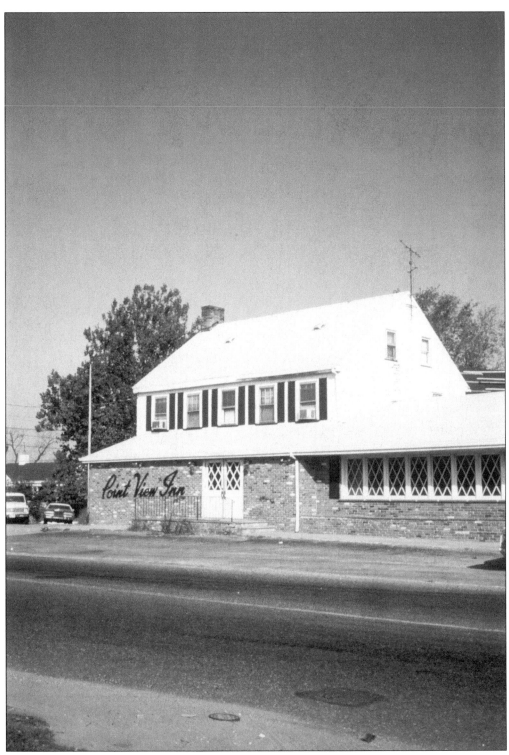

The Point View Inn was a popular destination for years when it was located at Marlton Pike and Greentree Road. (Cherry Hill Public Library.)

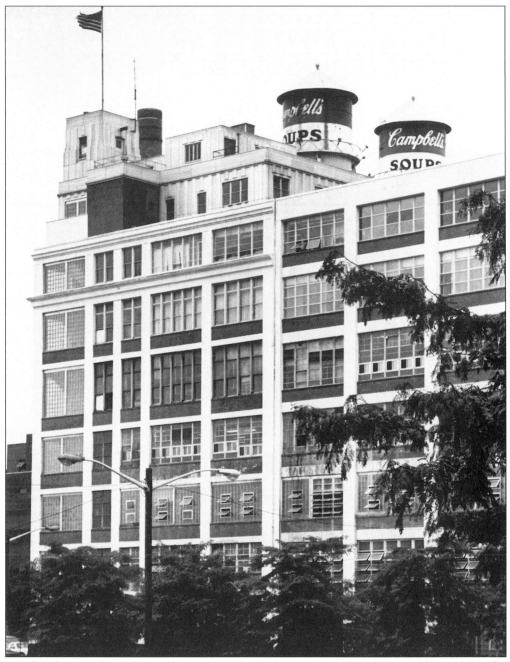

For decades, much of the produce grown on Delaware Township farms was bound for the Cambells Soup Company's canning and processing plant in Camden. The plant was demolished in the 1990s. (*Burlington County Times*.)

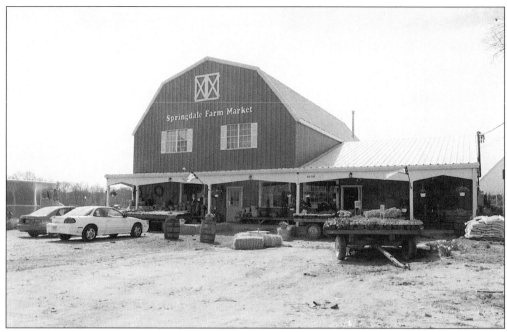

Spingdale Farm on Springdale Road was Cherry Hill's last "working" farm in the late 1990s. In 1931, there were 82 farms in Delaware Township. (Rachelle Omenson.)

The Ebert family's home, located adjacent to Springdale Farm, is believed to have been built by Joshua Ballinger in 1850.

Three
SUBURBIA

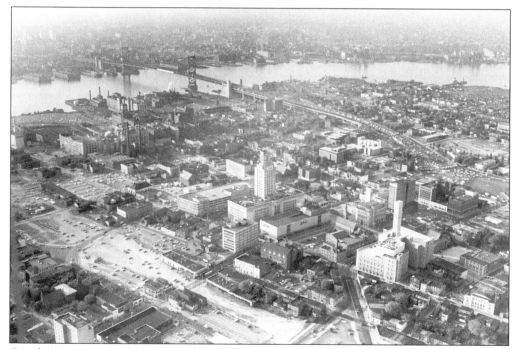

Camden's economic decline was already underway when this photograph was taken in the 1960s. Middle-class residents and businesses began leaving the city in the 1950s for growing suburbs such as Delaware Township, which would eventually replace Camden as Camden County's economic and political power base. (*Burlington County Times*.)

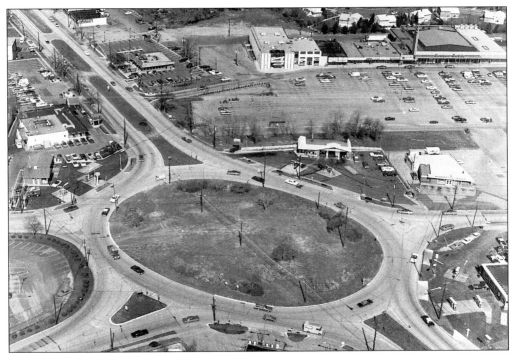

The Ellisburg Circle was once considered the center of Cherry Hill. The circle, along with the Race Track Circle, which stood about a half-mile west where Route 70 intersects Haddonfield Road, was removed in the 1990s to ease traffic congestion. (*Burlington County Times.*)

Before Ponzio's appeared on Route 70, locals dined at the Ellisburg Diner, pictured behind this car. (Cherry Hill Historical Commission.)

The COLWICK Model Home

Completely Furnished by

John Wanamaker

PHILADELPHIA

Colwick, New Jersey, is just beyond Merchantville on Maple Avenue, 5½ miles from the Bridge Plaza. Come straight out Federal Street from Camden by trolley, bus or motor.

Demonstrating that a home furnished with dependable furniture of genuine character and good taste need not be high in price. You will get many valuable suggestions for decorating your own home from this Wanamaker-furnished model home.

Colwick, built in the 1920s on Maple Avenue along Delaware Township's border with Pennsauken, was one of the township's first developments. (Lou Toth.)

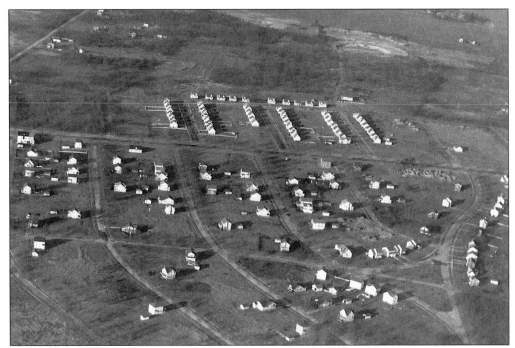

This aerial photograph shows Route 70, Park Boulevard, and Cooper Landing Road as the area appeared on February 20, 1946. (Cherry Hill Historical Commission.)

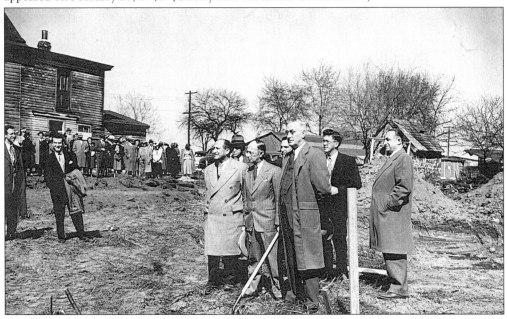

Delaware Township Mayor Henry Cranmer grasps the shovel at the ground-breaking for the Parkway Apartment Complex in January 1948. The 362-unit complex on Park Boulevard between Caldwell Road and Kings Highway, known today as the Waterford condominiums, was built to accommodate the large numbers of veterans returning from World War II who were in need of housing. The man to Cranmer's left is Thomas Edwards, a developer from Haddonfield who built the Brookfields development on Haddonfield-Berlin Road. (Herbert DuBois.)

This aerial photograph of the Barlow and Wilbur tracts was taken in the early 1950s. These neighborhoods are among the oldest in Cherry Hill and are situated along the township's border with Merchantville and Pennsauken. (Lou Toth.)

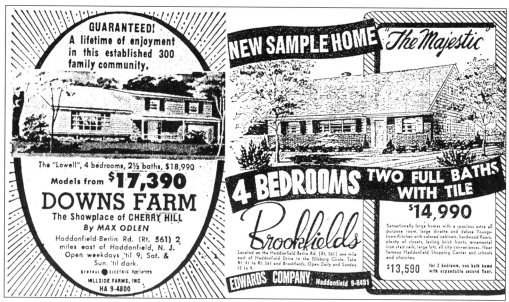

By the mid-1950s, residential tract housing appeared throughout Delaware Township. Pictured here are advertisements for the Downs Farm and Brookfield developments. (Cherry Hill Historical Commission.)

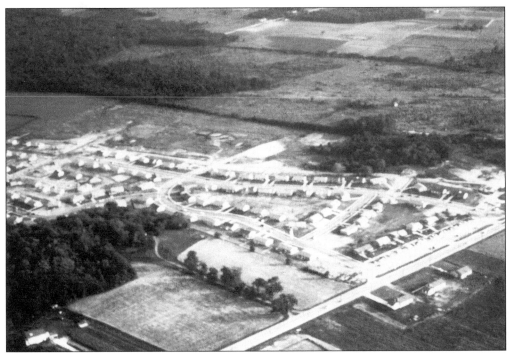

This aerial photograph was taken during the first phase of the Kingston Estates development in October 1954. At the bottom is Kings Highway; Chapel Avenue is the long street at the top. (Lou Toth.)

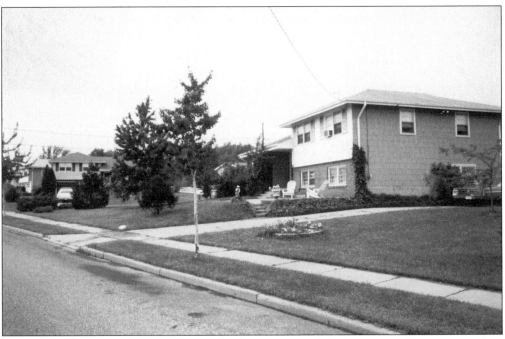

These homes in the Kingston Estates development typified the types of homes prevalent throughout Delaware Township in the 1950s. (Cherry Hill Historical Commission.)

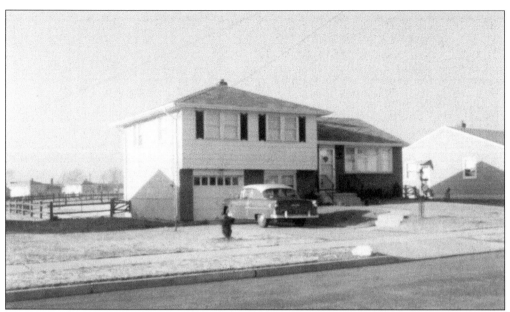

This house on East Valleybrook Road in the Brookfield development exemplified the type of homes built throughout Delaware Township in the 1950s. (Walt Staib.)

BROOKFIELDS, INC.

APPROXIMATE CASH REQUIRED

	Split Level		Rancher		Four Bedroom	
	V. A. (30 yr)	FHA (30 yr)	V. A. (30 yr)	FHA (30 yr)	V. A. (30 yr)	FHA (30 yr)
Sales Price	$14850	$14850	$15000	$15000	$15590	$15590
Mortgage	14100	12650	14200	12800	14800	13200
Down Payment	750	2200	800	2200	790	2390
*Guaranteed Settlement Costs	490	490	490	490	490	490
Cash Required	$1240	$2690	$1290	$2690	$1280	$2880

ESTIMATED MONTHLY PAYMENTS

	Split Level		Rancher		Four Bedroom	
Principal and Interest	$71.49	$64.14	$71.99	$64.90	$75.04	$66.92
F. H. A. Insurance		5.14		5.21		5.37
Fire Insurance	2.96	2.84	3.19	2.88	3.28	2.95
Sewer	4.00	4.00	4.00	4.00	4.00	4.00
Estimated Taxes	18.00	21.00	18.00	21.00	18.50	21.50
TOTAL MONTHLY PAYMENTS	$96.45	$97.12	$97.18	$97.99	$100.82	$100.74
Average Saving	39.16	35.14	39.44	35.55	41.11	36.66
NET MONTHLY COST	$57.29	$61.98	$57.74	$62.44	$59.71	$64.08

Conventional Financing Available — One-third Down — Mortgage 4¾%

*The above guaranteed figure covers all costs pertaining to settlement including prepayment of taxes, sewer, 3 year fire insurance policy, etc.
The assessment on which taxes are based has not been fixed. The tax stated above is therefore, an estimate and is not guaranteed. All veterans under State of New Jersey law are eligible for a $500 tax exemption on assessed property value. This has been taken into consideration in the above tax figures.

With as little as $50 down, prospective home buyers could purchase a split-level, Ranch, or Cape Cod-style home in the Brookfield development. (Walt Staib.)

TOWNSHIP of DELAWARE, N. J.

BUILDING PERMIT

ISSUED FOR THIS WORK

Location and Use

VOID IF ACTIVE WORK IS NOT COMMENCED WITHIN SIX (6) MONTHS FROM DATE OF ISSUE

The construction of this building must be in accordance with the approved plans and specifications which are a part of this permit and must be kept on the job accessible to the Inspector.

The kind, type, use, etc., are recorded in this department. The construction of this building other than in accordance with the provisions of this permit is a violation of the building ordinances.

Contractor _____ Permit No. _____ Date _____

Address _____

This Placard (which is NOT A PERMIT — but merely issued with permit, for convenience, as evidence of such issue) must be posted in a conspicuous place on the work — easily visible from the principal street, and <u>well secured if exposed</u> to the weather — <u>during the entire operation</u> authorized. It will be removed by the Building Inspector, upon completion of the work authorized.

By the 1950s, township officials issued building permits by the thousands each year. (Walt Staib.)

The Sweeton House on Kings Highway was designed by famed architect Frank Lloyd Wright, and was built in 1950 for a naval architect. It is the only Wright-designed house in southern New Jersey. (Cherry Hill Historical Commission.)

60

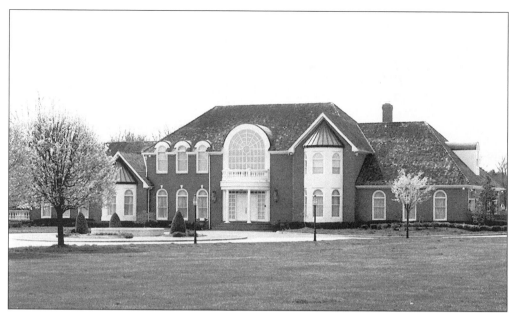

Many of the homes built in Cherry Hill between the late 1960s and the end of the 1990s resembled mansions and were priced near $1 million. (Rachelle Omenson.)

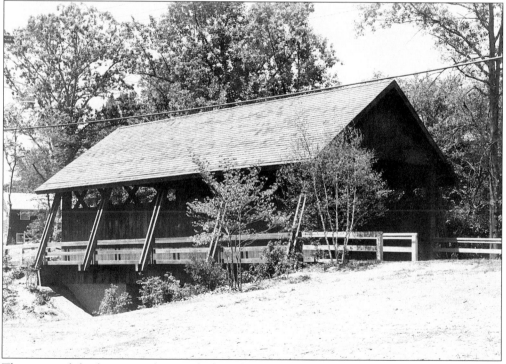

The covered bridge over the north branch of the Cooper River in the Barclay Farms development was designed by architect Malcolm Wells and built by developer Bob Scarborough, who also built Barclay Farms and Wexford Leas. The first covered bridge built in New Jersey in more than 90 years, the span was dedicated on February 14, 1959. (Cherry Hill Historical Commission.)

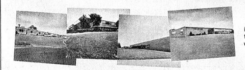

The Cherry Hill Township Advisory Board placed this advertisement in newspapers across the nation in the mid-1960s to encourage businesses to relocate to Cherry Hill. Many did, and Cherry Hill became one of the hottest commercial destinations in the country. (Cherry Hill Historical Commission.)

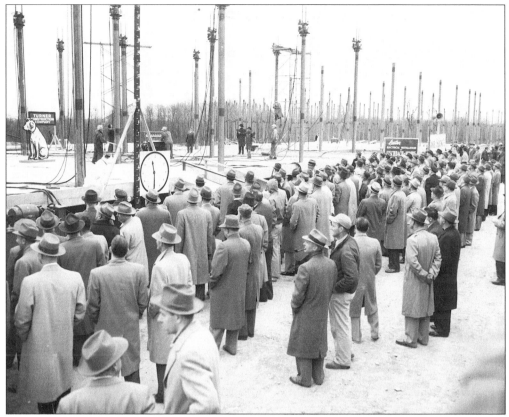

Radio Corporation of America (RCA) employees gather to watch contractors install electrical service at the company's new Delaware Township facility in the early 1950s. (Cherry Hill Historical Commission.)

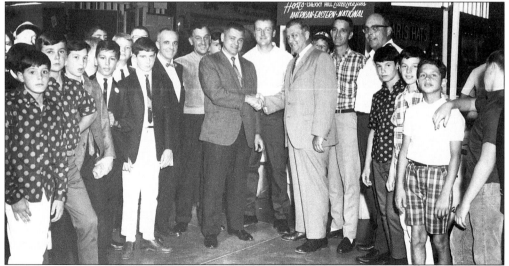

The Cherry Hill American, Eastern, and National Little Leagues hosted the 1966 Eastern Regional Little League Baseball Tournament. Mayor John Gilmour greets some of the players and coaches from the visiting teams. (Eva Gilmour.)

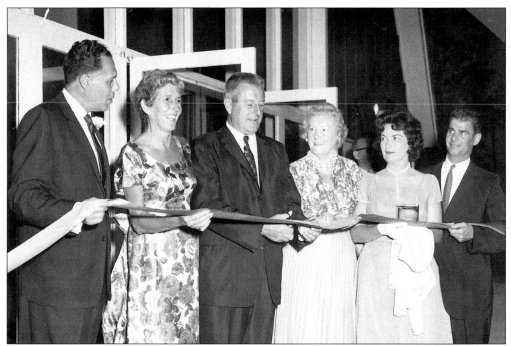

Delaware Township Mayor Christian Weber cuts the ribbon during the grand opening of the Barclay Farms Shopping Center on Route 70 in November 1960. (Cherry Hill Historical Commission.)

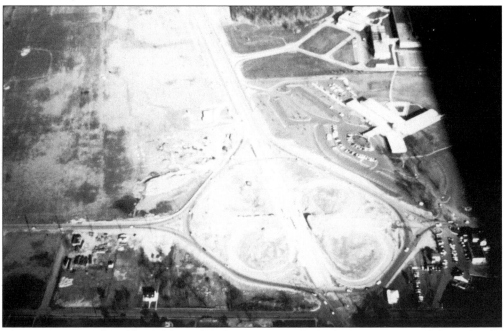

The intersection of Haddonfield Road and Route 38 is shown here as it appeared from the sky on October 1, 1954. The Cherry Hill Inn opened shortly before and the traffic circle was in the process of being removed in anticipation of the heavy traffic. The vacant land at the left is where the Cherry Hill Mall was built seven years later. (Lou Toth.)

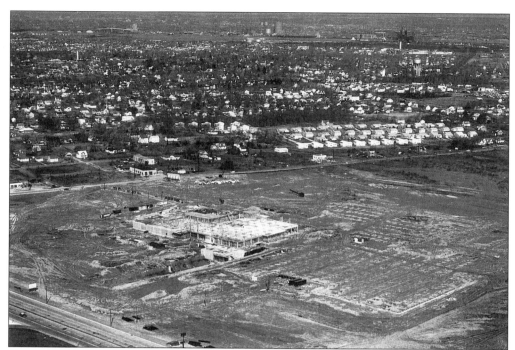

The Cherry Hill Mall slowly takes shape at Route 38 and Haddonfield Road in these photographs taken on March 11 and May 4, 1961. The mall, built by the Rouse Co. of Columbia, MD, was one of the first indoor malls in the nation, attracting shoppers from along the East Coast when it opened. The name for the mall was derived from the Cherry Hill Inn across Route 38. (The Rouse Co.)

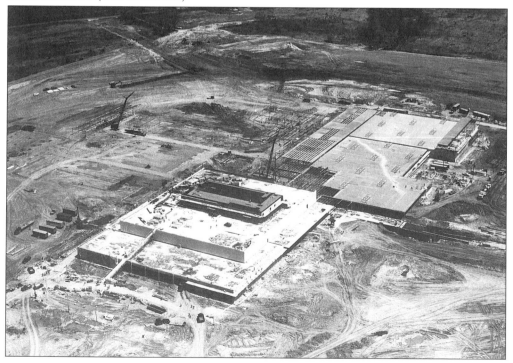

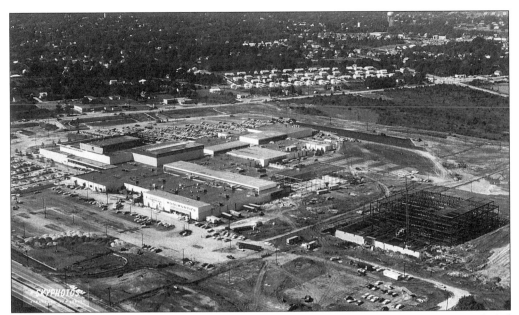

By October 5, 1961, much of the mall was occupied. The original anchor tenants included Strawbridge & Clothier and F.W. Woolworth. (The Rouse Co.)

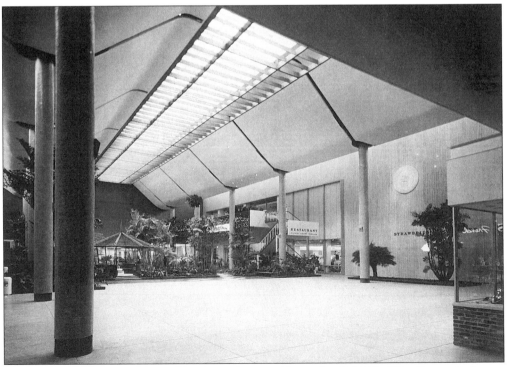

The inside of the court of the mall is shown here on November 9, 1961. (The Rouse Co.)

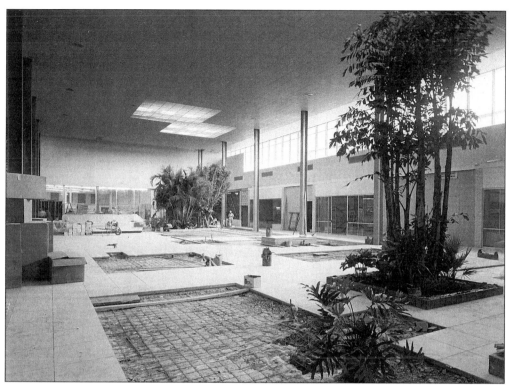

Construction on one of the walkways through the mall continued as this October 5, 1961 image documents. (The Rouse Co.)

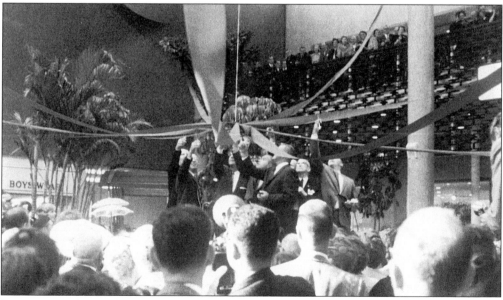

Rouse Co. and township officials cut the ribbon for the mall at the official grand opening in October 1961. The mall was welcomed by township officials seeking commercial ratables to help pay for the cost of services for the large numbers of people moving into Delaware Township. (The Rouse Co.)

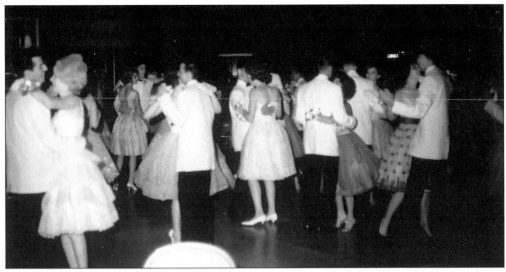

Since the mall was the focal point of suburbia, it made sense to hold a high school prom there. The Cherry Hill High School Junior Prom of 1962 was held in the mall's center court. (Sherry Wolkoff.)

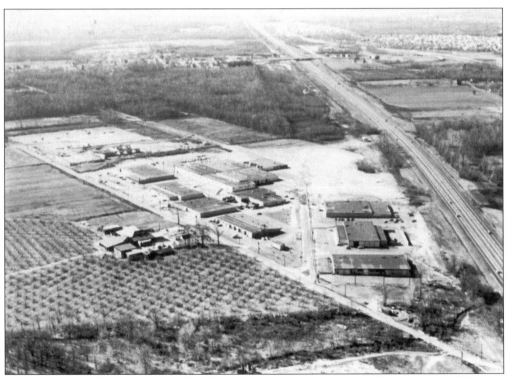

The influx of new businesses to Delaware Township included industrial concerns as well as new stores. This is an aerial photograph of the Cherry Hill Industrial Park, which attracted nationally known companies such as the Esterbrook Pen Co. (Cherry Hill Public Library.)

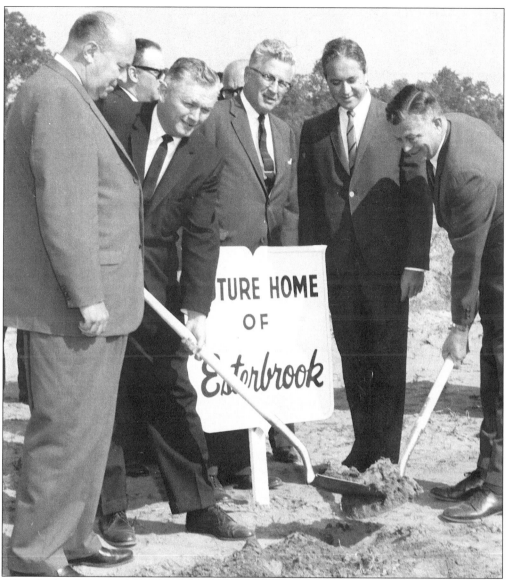

Officials break ground for the Esterbrook Pen Co., one of Camden's longest-standing businesses. It relocated to Delaware Township in the 1960s. (Cherry Hill Public Library.)

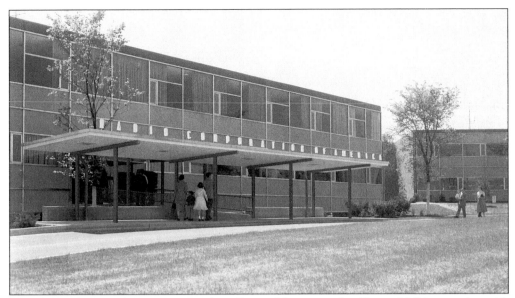

RCA located some of its operations along Route 38 next to the Cherry Hill Inn in the mid-1950s. The site is now the location of the Hillview Shopping Center. (Cherry Hill Historical Commission.)

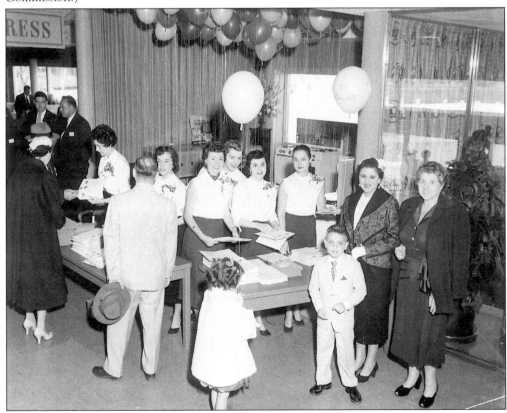

Employees attend an open house at the RCA facility in Delaware Township in the 1950s. (Cherry Hill Historical Commission.)

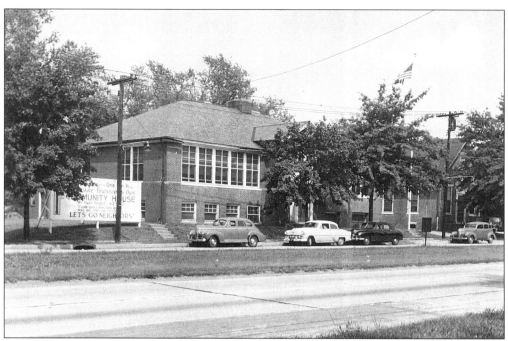

This is the old town hall and Ellisburg School in the 1940s. The sign adjacent to the school seeks the public's help in raising money for a new community house for Delaware Township. (Cherry Hill Historical Commission.)

Workers tear down the old town hall and Ellisburg School in January 1968. The town hall was erected in 1885. The school site housed a school since 1831 on land donated by Joseph Ellis. (Lou Toth.)

By the early 1970s, some of the township remained rural. This is the intersection of Kings Highway and Church Road, photographed in 1971. (Cherry Hill Historical Commission.)

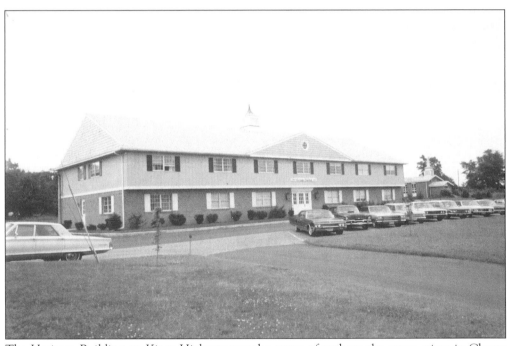

The Heritage Building on Kings Highway was the scene of perhaps the worst crime in Cherry Hill's history. On June 21, 1972, Edwin Grace, 33, embarked on a 15-minute shooting barrage, resulting in the deaths of six men and the wounding of six others. Grace died of a self-inflicted gunshot wound nearly three weeks after the spree. (Cherry Hill Public Library.)

Four

NIGHTLIFE AND
RECREATION

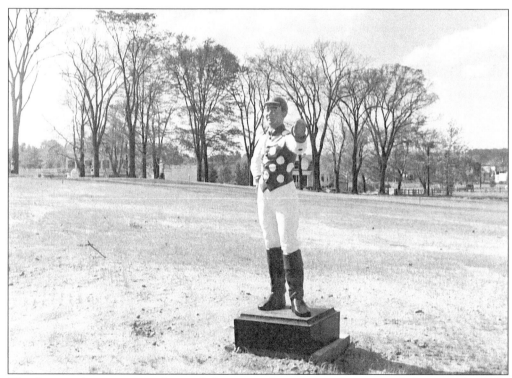

This lawn jockey was one of several that greeted visitors as they entered the grounds of the Cherry Hill Inn from Route 38 and Haddonfield Road. The inn operated at the site from 1954 until 1992. (Haddonfield Public Library.)

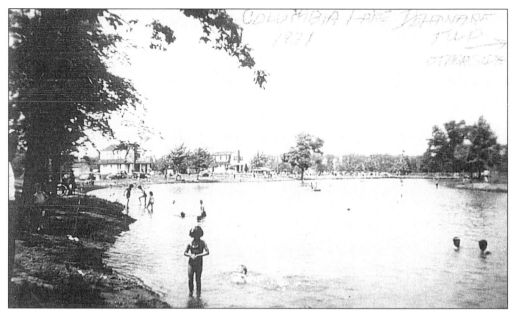

Columbia Lake was a popular swimming spot in the 1930s. Today the lake is home mostly to waterfowl. (Lou Toth.)

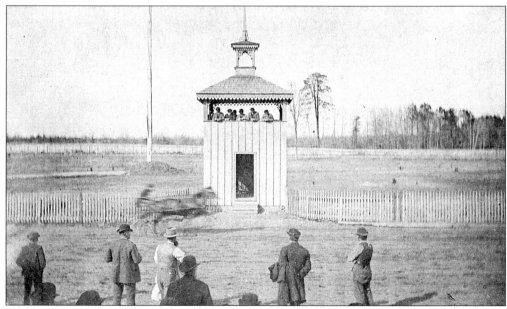

Many believe Garden State Park has been the only place in Delaware Township to enjoy the horse races, but this 1883 photograph shows that horse racing thrived in the area before the 20th century. The Merchantville Race Track was located along Chapel Avenue (formerly known as Whiskey Road) on the site of the Merchantville Country Club until the 1920s. An 1877 map of Delaware Township shows a track known as the "Half Mile Track" on the Woodland Farm, now the site of the New Jersey Transit train station adjacent to Garden State Park. (Camden County Historical Society.)

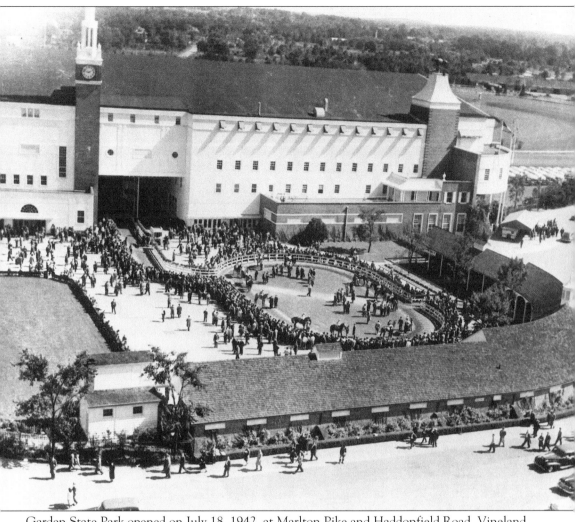

Garden State Park opened on July 18, 1942, at Marlton Pike and Haddonfield Road. Vineland businessman Eugene Mori developed the track despite a shortage of labor and material due to the war effort. In its first 49-day season, nearly 440,000 people attended the races and bet a daily average of $528,217. (Garden State Park.)

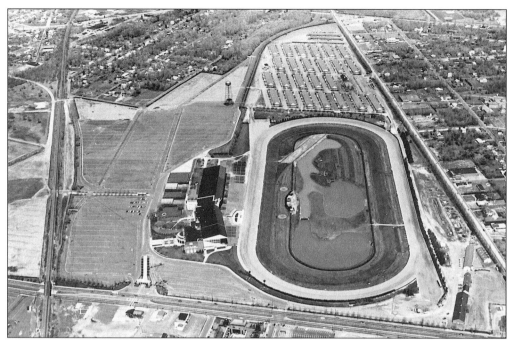

This aerial photograph was taken in the 1960s. The Rickshaw Inn is at the bottom center. The Race Track Circle, where Route 70 intersected Haddonfield Road and Grove Street, was removed in the early 1990s. (Garden State Park.)

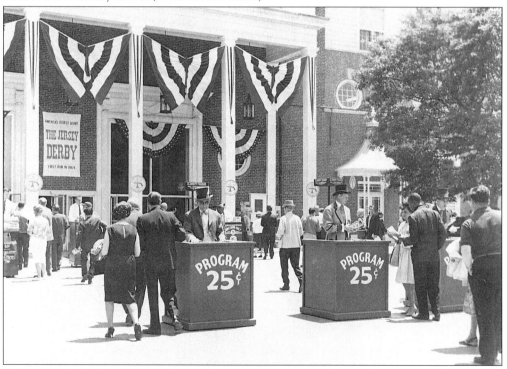

The Jersey Derby Race was held annually for many years at Garden State Park. Here, people enter the grandstand to watch the 1963 Derby. (Garden State Park.)

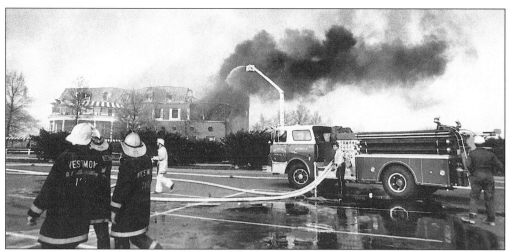

A massive fire gutted the original Garden State Park on April 14, 1977, resulting in two deaths, more than 20 injured, and an estimated $20 million in damage. The fire broke out following the sixth race, and was fought by fire departments from many towns surrounding Cherry Hill. (*Burlington County Times*.)

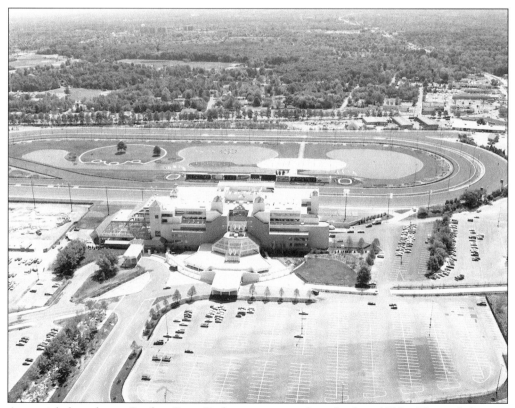

An aerial shot shows Garden State Park as it appeared in the late 1980s. The park hosts a weekly flea market and the annual New Jersey State Fair. (*Burlington County Times*.)

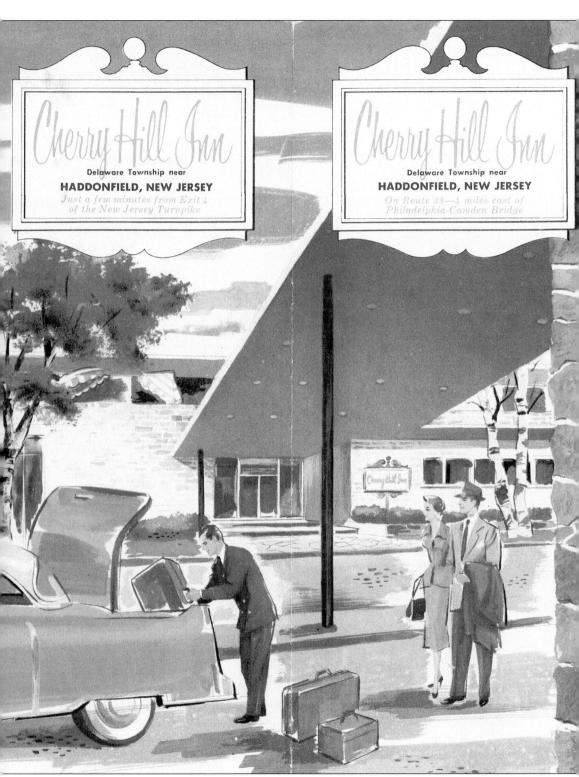

This brochure detailed the amenities of the Cherry Hill Inn and its proximity to the shopping

A New Idea
in Old Fashioned Hospitality

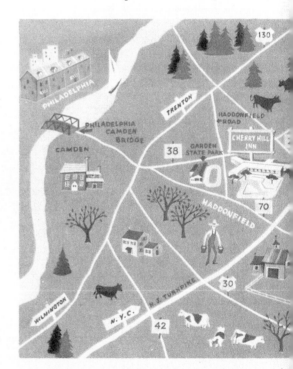

Welcome . . . to a delightful experience in country living . . . a beautiful modern Inn on a picturesque fifty-acre country estate. Everything is here for your personal enjoyment—superb accommodations, air-conditioning throughout, decor by Dorothy Draper, sports and recreations on the grounds, a magnificent scenic setting; gracious dining, dancing and entertainment . . . and all just 15 minutes from downtown Philadelphia.
For a complete vacation or brief stopover, Cherry Hill offers a distinctive and pleasant holiday.

Cherry Hill Inn is located on New Jersey Route 38 at Haddonfield Road, just 4 miles from the Philadelphia-Camden Bridge. It is adjacent to Garden State Park and less than 5 minutes from Exit 4 of the New Jersey Turnpike; convenient also to the highways from Atlantic City.

and historical attractions in Philadelphia. (Cherry Hill Historical Commission.)

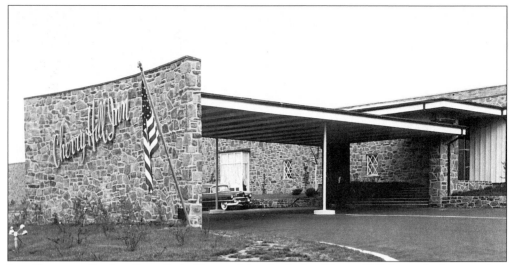

In addition to Garden State Park, Eugene Mori built the Cherry Hill Inn, which opened in October 1954 on the site of Civil War veteran Abraham Browning's 134-acre farm known as Cherry Hill. Browning built his home on the site in 1875 and purportedly named it for the cherry trees on the property. The hotel closed abruptly in 1992, and was destroyed by fire in April 1996. A 24-screen movie theater now occupies the site that gave Cherry Hill its name. (George Stein.)

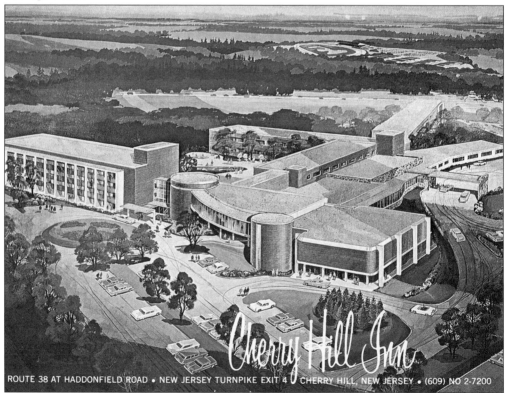

ROUTE 38 AT HADDONFIELD ROAD • NEW JERSEY TURNPIKE EXIT 4 • CHERRY HILL, NEW JERSEY • (609) NO 2-7200

The back of the brochure, which highlighted the amenities of the Cherry Hill Inn, carried this artist's rendering of the hotel. (Cherry Hill Historical Commission.)

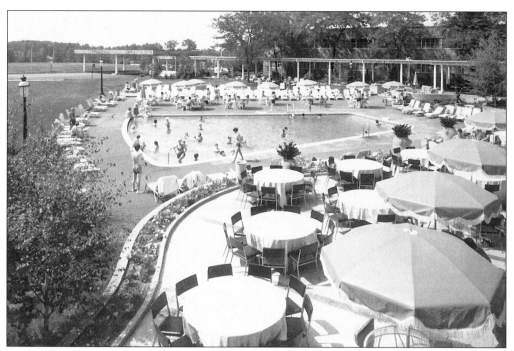

During the summer months, the outdoor pool at the Cherry Hill Inn was a source of enjoyment for hundreds of people. (Cherry Hill Public Library.)

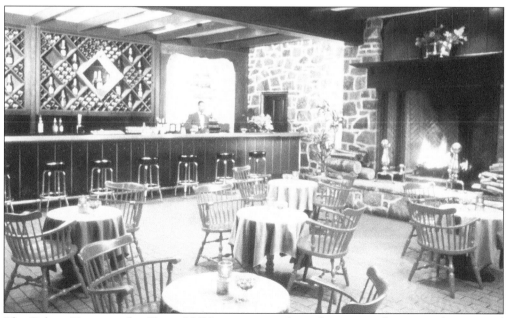

The Colony Tavern at the Cherry Hill Inn was a popular gathering spot for visitors from around the country, as well as locals. (Cherry Hill Public Library.)

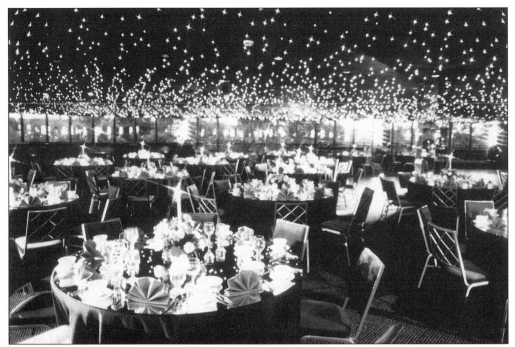

Perhaps the most magnificent room at the Cherry Hill Inn was the Starlight Ballroom, the scene of countless events such as wedding receptions and high school proms. (Cherry Hill Public Library.)

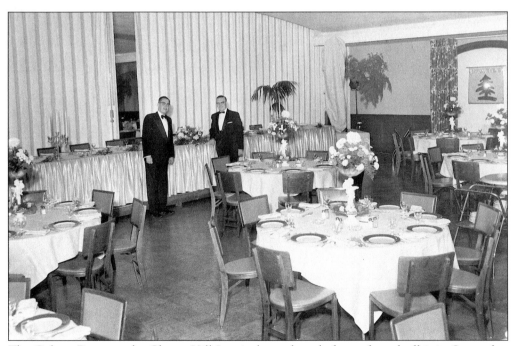

The Colony Room at the Cherry Hill Inn is shown here before a formal affair in September 1957. (Cherry Hill Historical Commission.)

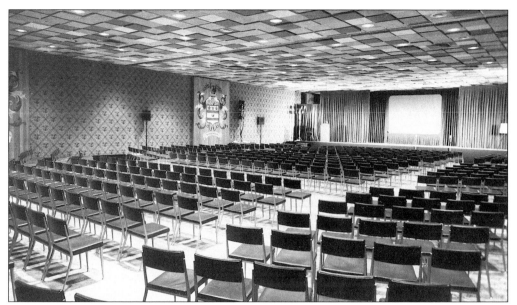

The Cherry Hill Inn's Presidential Ballroom was the scene of many conferences and lectures held by companies and groups from around the nation. (Cherry Hill Historical Commission.)

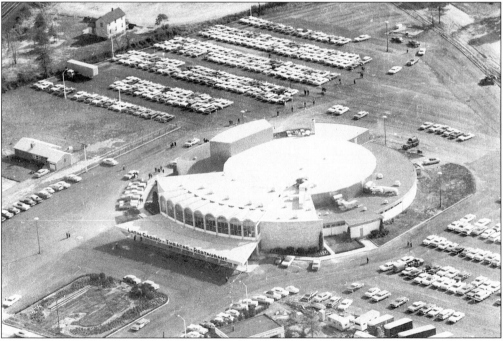

The Latin Casino restaurant theater opened on Route 70 across from Garden State Park in October 1960. The showplace, which was founded in Philadelphia in 1950, hosted big-name entertainers such as Frank Sinatra, Dean Martin, the Supremes, and Liberace. It closed in June 1978 because of rising operating costs and competition from casino gambling in Atlantic City. It reopened as a discotheque known as Emerald City before closing permanently in December 1982. The site is now the location of the national headquarters of Subaru of America. (Cherry Hill Historical Commission.)

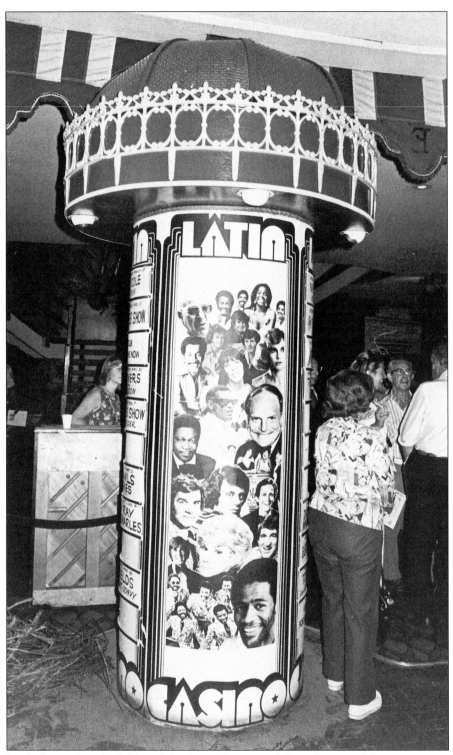

This kiosk, located in the lobby of the Latin Casino, celebrated some of the entertainers who appeared on its stage. (*Burlington County Times.*)

Another popular restaurant in Delaware Township was Cinelli's Country House, located on Haddonfield Road across from the Cherry Hill Inn. The restaurant was a farmhouse before it was converted into a restaurant in 1934, and it eventually contained five dining rooms and three bars. It was demolished in August 1988 to make room for a seven-story office building. (Haddonfield Public Library.)

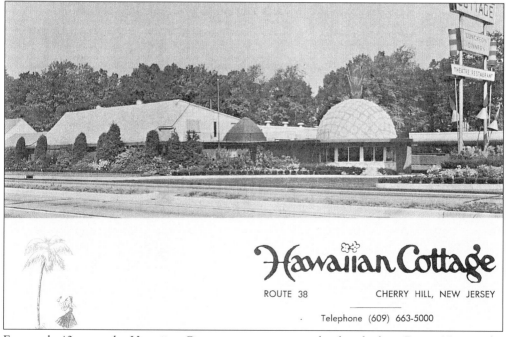

For nearly 40 years, the Hawaiian Cottage restaurant was a landmark along Route 38, near the Cherry Hill Mall. It was known for the distinctive yellow, pineapple-shaped dome on its roof and Hawaiian atmosphere. The restaurant was destroyed by fire on July 1, 1978, after 40 years of business. (Lisa Perrone and Eileen Stone.)

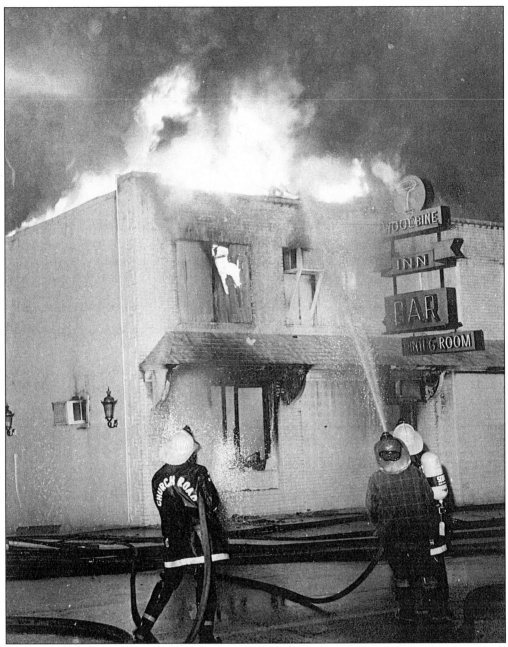

Fire fighters from the Church Road Fire Co. battle a blaze at the old Woodbine Inn, which stood on Church Road at State Street until the late 1960s. The Woodbine today is located on Route 73 in Pennsauken, where it remains one of southern New Jersey's premier night spots. (Cherry Hill Historical Commission.)

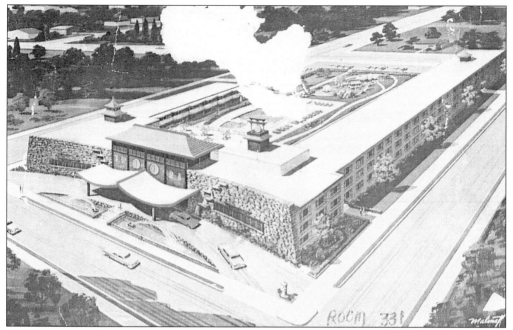

The Rickshaw Inn stood on Route 70 across from Garden State Park and prospered until the late 1970s, when gambling started in Atlantic City. It was closed by an electrical fire in 1988, and was demolished in early 1999. (Carol Genzano.)

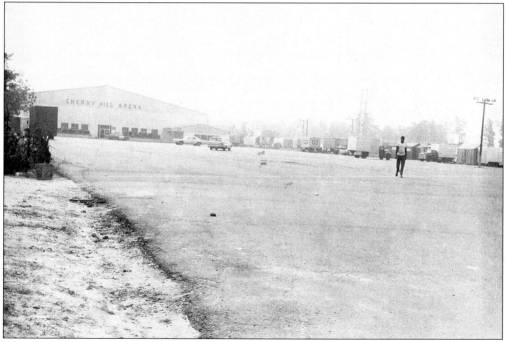

Cherry Hill Arena, known originally as the Ice House, opened in 1959 at Brace and Haddonfield-Berlin Roads. It was the home of the minor league New Jersey Devils ice hockey team, and hosted closed-circuit TV boxing events and a variety of musical acts. It is now the site of a shopping center. (Cherry Hill Historical Commission.)

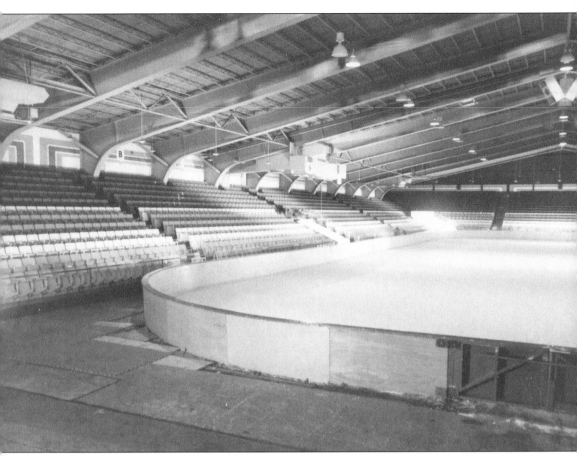

This is the inside of the Cherry Hill Arena, which was later known as the Centrum. (Cherry

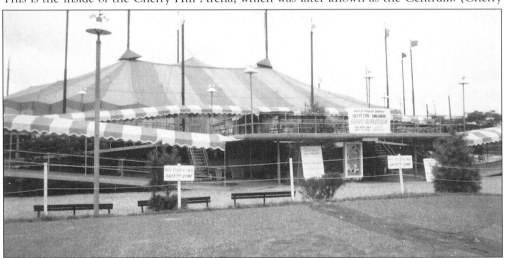

The Camden County Music Fair was located at Brace and Borton Mill Roads and featured nationally known entertainers. The summer playhouse's first performance in June 1956 featured Joyce Randolph of the Jackie Gleason television show. The Music Fair closed in 1969 due to lagging attendance. (Cherry Hill Public Library.)

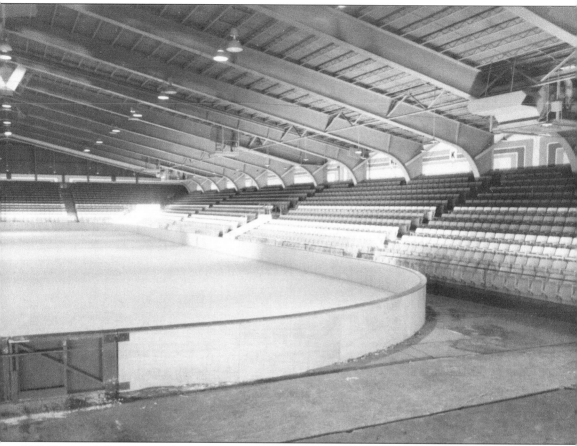

Hill Historical Commission.)

The sign in front of the Camden County Music Fair advertised some of the featured acts of the day. (Cherry Hill Public Library.)

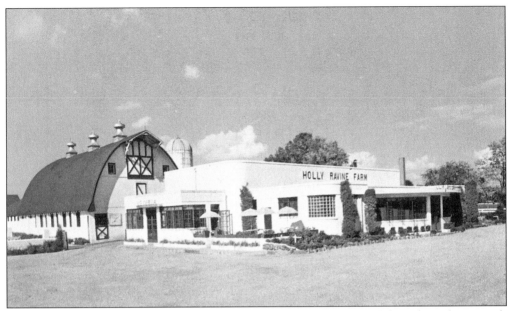

The Holly Ravine Farm and Cowtail Dairy Bar was a fixture at Springdale and Evesham Roads for decades. Operated by former Mayor John Gilmour and his wife, Eva, the dairy bar was known for its ice cream and petting zoo for more than 50 years until it closed at the end of 1987. About 40 acres of the farm remain. (Eva Gilmour.)

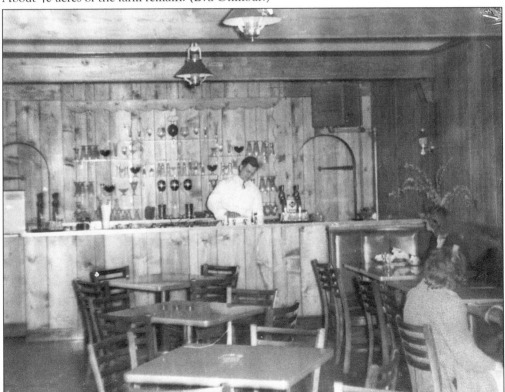

This is the inside of the Cowtail Dairy Bar. (Eva Gilmour.)

Five

PEOPLE

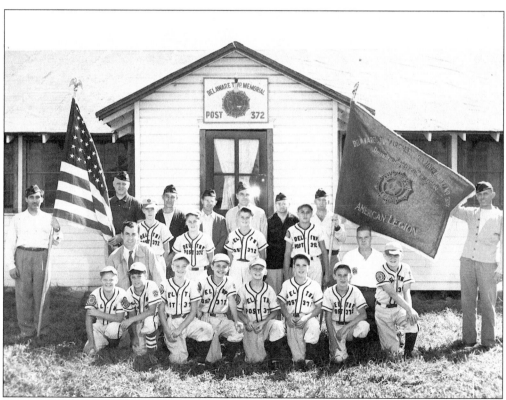

This is one of Delaware Township's old baseball teams in the 1950s. (Cherry Hill Historical Commission.)

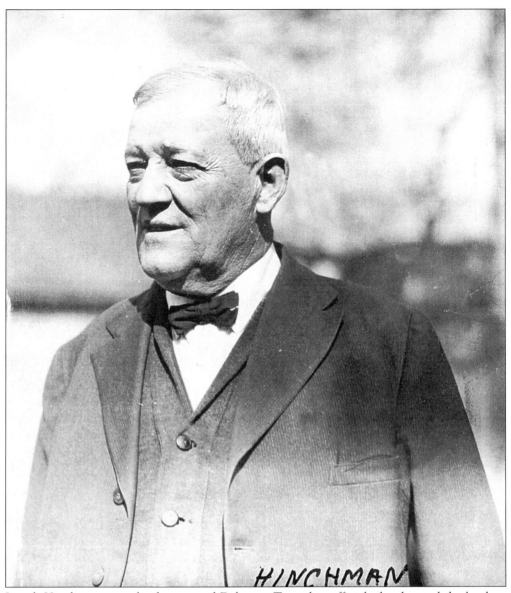

Joseph Hinchman was a landowner and Delaware Township official who donated the land on which the Hinchman School was located. The Hinchman section of the township also bears his name. (Lou Toth.)

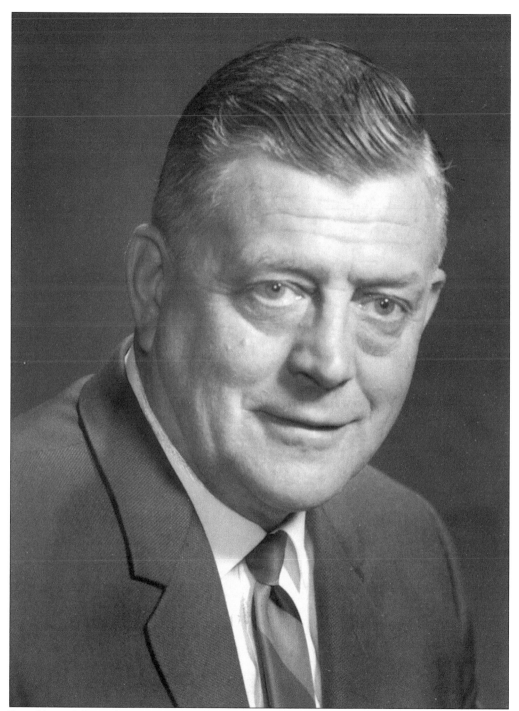

Republican John Gilmour served as Cherry Hill's first mayor and is widely credited for shaping Cherry Hill's development. He was appointed to the Delaware Township Planning Board in 1955 and then served as a Delaware Township Commissioner from 1959 to 1963. He was mayor from 1963 until 1971. Gilmour died in 1993 at the age of 85, and was also well known as the owner of Holly Ravine Farm and the Cowtail Dairy Bar. (*Burlington County Times.*)

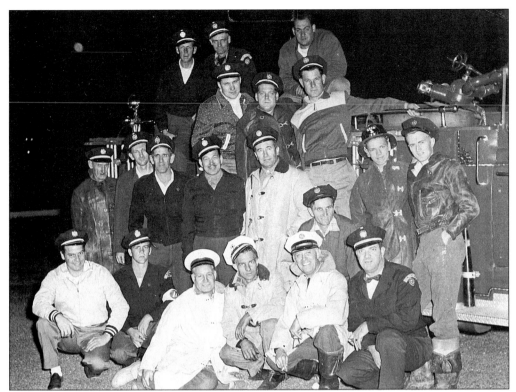

Members of the Church Road, East Merchantville, and Woodland Fire Companies pose for this photograph in the 1950s. These were three of the seven volunteer fire companies that formed in Delaware Township between 1914 and 1948. (Dick Harley.)

Christian Weber (center) was mayor of Delaware Township for 12 years, from 1951 to 1963. He held the office during a time when many businesses located to the township, including the Cherry Hill Mall and RCA. (Cherry Hill Historical Commission.)

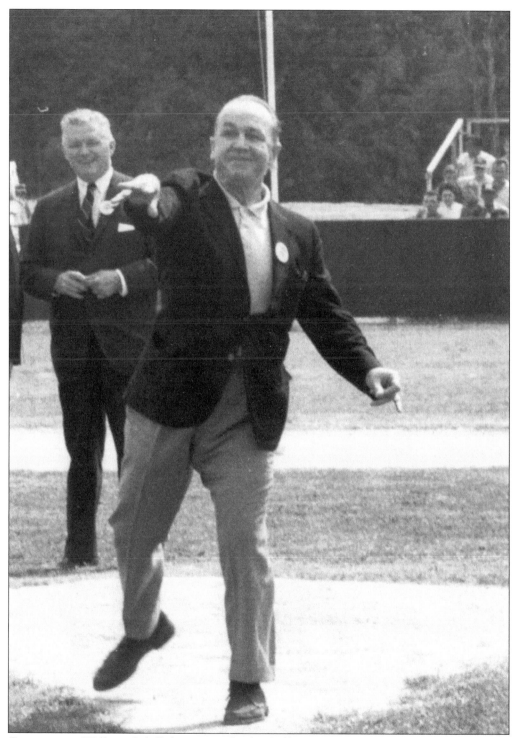

Congressman William Cahill throws out the first ball at a Little League baseball contest in the 1960s. Cahill represented Cherry Hill in Congress during the 1960s and served as governor of New Jersey from 1970 to 1974. (Cherry Hill Historical Commission.)

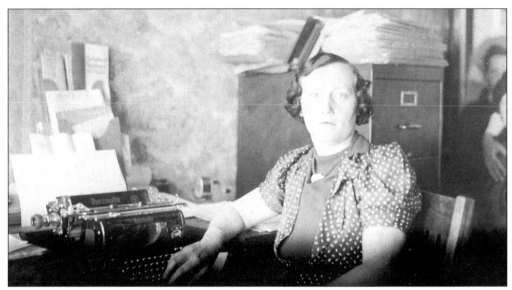

Township Clerk Margaret Wermuth poses in her Cooper Avenue home in the 1930s. Wermuth served as township clerk for 37 years, from 1926 to 1963, witnessing first-hand the vast change that swept through the township. She died on November 26, 1977, at the age of 76. (Cherry Hill Historical Commission.)

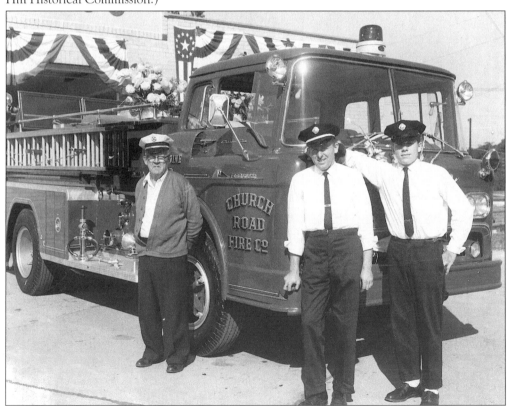

Church Road Fire Co. founder Rue Meng and two of his relatives pose in front of the Church Road firehouse in the 1950s. (Catherine Meng Mauer.)

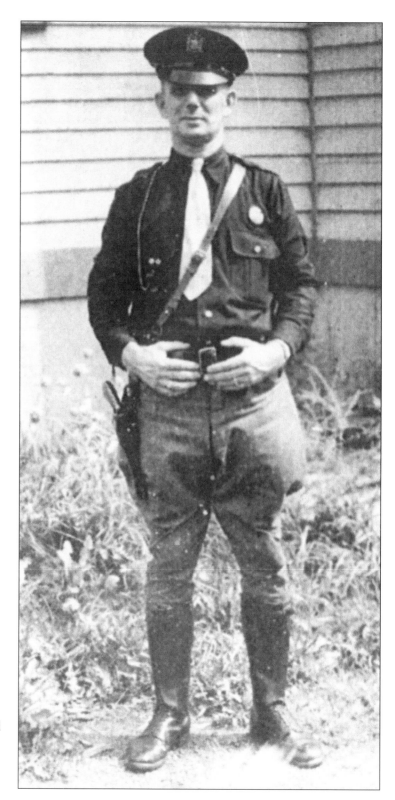

John S. Branin was Delaware Township's first patrolman when the department was organized on May 1, 1924. He was named chief that autumn, and five special officers were named to serve with him. (Bill Lattiere.)

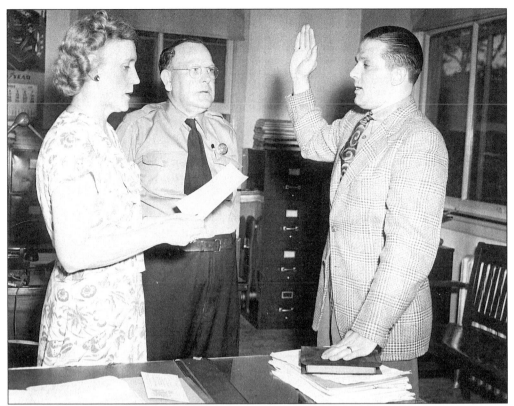

This photograph of John McAllister, Police Chief Lynch, and Township Clerk Margaret Wermuth was taken on June 25, 1947. (Cherry Hill Historical Commission.)

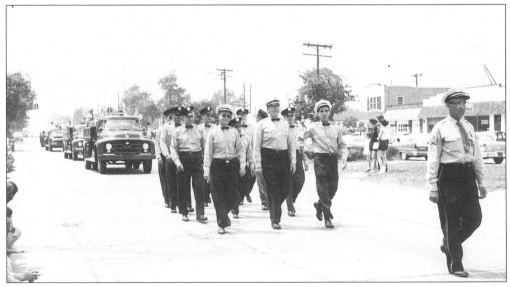

Members of the Woodcrest Fire Co. walk in a parade along Marlton Pike in the 1950s. The Woodcrest Fire Co. was the first of the township's seven volunteer fire departments to organize in 1914. Its original firehouse was located on the present site of the PATCO Woodcrest station. (Ron Judlicka.)

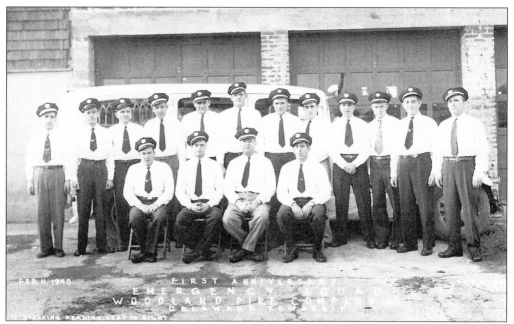

Members of the Woodland Fire Co. emergency squad pose for a photograph in 1948. (Carl Genzano.)

Children celebrate Christmas at the Woodland Fire Co.'s annual Christmas party in the 1950s. (Carol Genzano.)

Delaware Township fire personnel pose for a photograph taken between 1944 and 1948. (Ron Judlicka.)

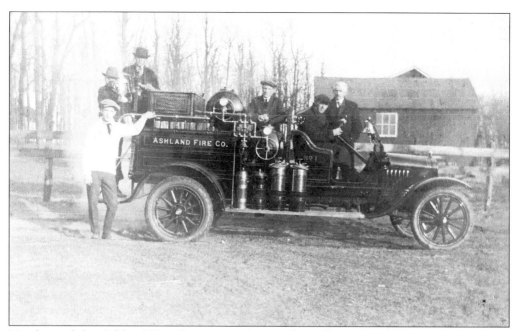

Members of the Ashland Fire Co. pose with a truck in the 1920s. (Cherry Hill Historical Commission.)

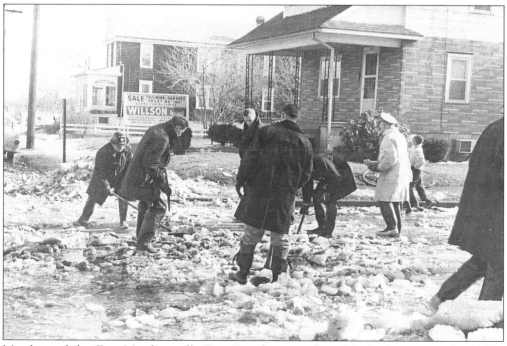

Members of the East Merchantville Fire Co. chop ice along Maple Avenue in the 1950s. (Dick Harley.)

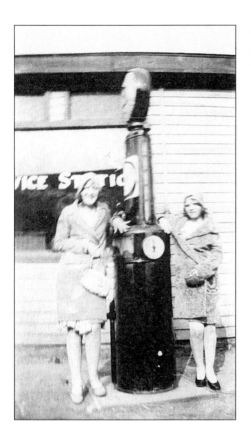

Two ladies pose in front of a gas station on Chapel Avenue in the 1930s. The gas station was located near Lena's Cafe. (Carol Genzano.)

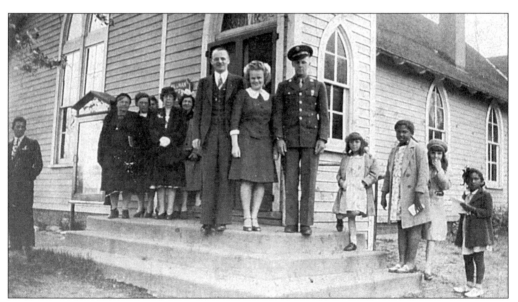

People gather after a wedding on the steps of the Hillman Baptist Church in the early 1940s, The church was a focal point of life for much of the early 20th century in the eastern part of Delaware Township. (Frances Gaines Cryer.)

The Gaines children are, from left to right, Frances, James, and Helena. They are posing on the Willits Farm c. 1940. The rear of the Hillman School is visible in the background. (Frances Gaines Cryer.)

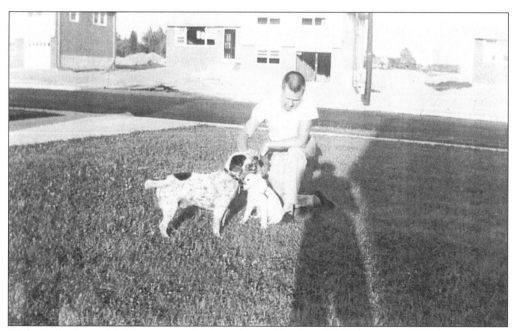

Walt Staib plays with his dogs on the front lawn of his Brookfield home in 1957. Note the two homes across the street still under construction. (Wait Staib.)

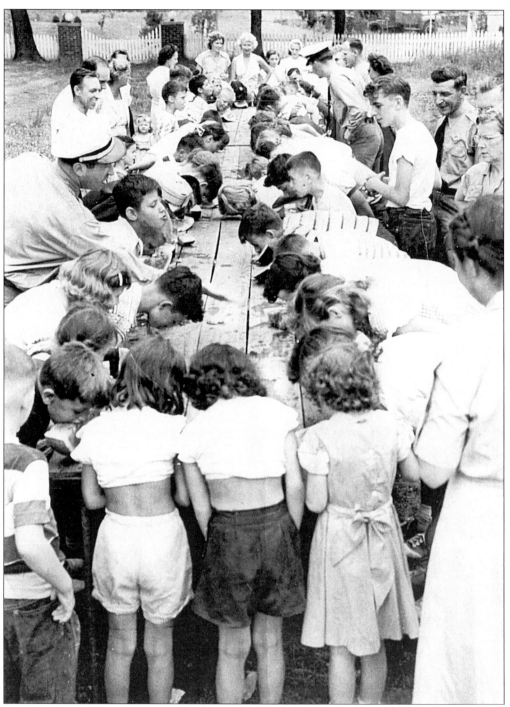

Residents of the Wilbur Tract participate in a watermelon eating contest on the grounds of the East Merchantville Fire Co. on July 4, 1951. (Dick Harley.)

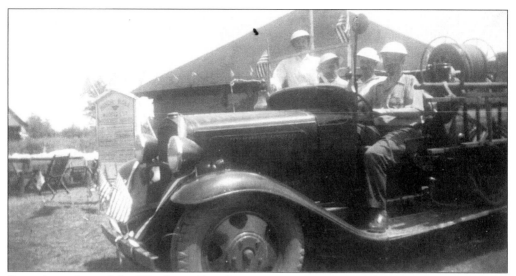

Several members of the Woodcrest Fire Co. pose on a company truck in 1948. Note the civil defense helmets and the sign honoring fire company members who served in the military during World War II. The company's original firehouse also can be seen in the foreground. (Ron Judlicka.)

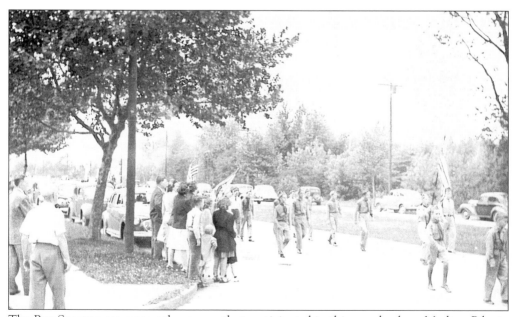

The Boy Scouts were among the groups that participated in this parade along Marlton Pike in the 1940s. (Lou Toth.)

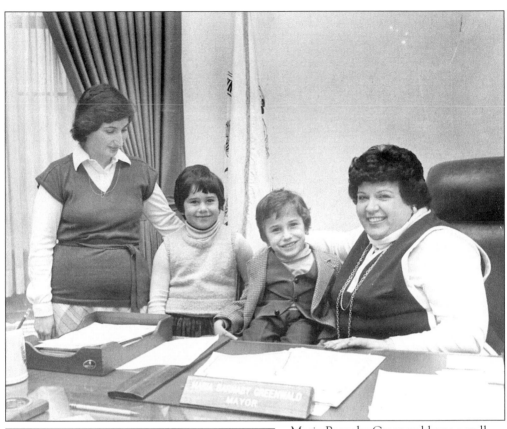

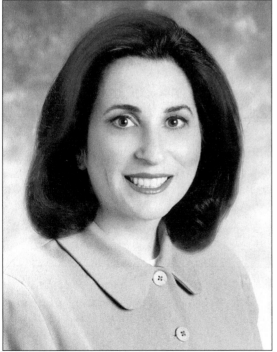

Maria Barnaby Greenwald was a well-known and popular figure in Cherry Hill and Camden County political circles. She served as the first mayor of the township directly elected by the people, as a Camden County freeholder, and as Camden County surrogate. She died in a car accident in January 1995. (Cherry Hill Township.)

Susan Bass Levin was elected to the Cherry Hill Township Council in 1985 and was elected to her first four-year term as mayor in 1987. She was reelected mayor in 1991 and 1995. An attorney, Levin led the Cherry Hill-Camden delegation to the President's Summit on Volunteerism in Philadelphia and has been active in Democratic politics on the state and national levels.

Six

COMMUNITY
FOUNDATIONS

The current township building on Mercer Street opened in 1964 to accommodate the growing township staff and police department needed to serve the burgeoning population. (Cherry Hill Public Library.)

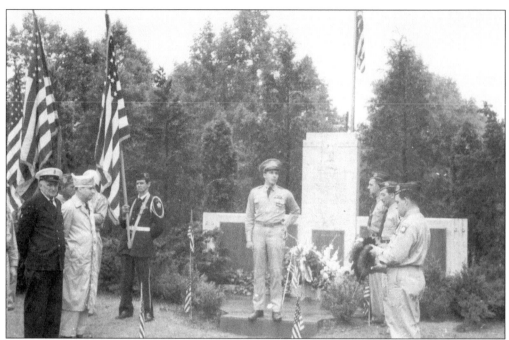

Veterans and others raise the flag above the township veterans' monument on July 4, 1953. The monument was located near the present site of Ponzio's restaurant on Route 70. (Cherry Hill Historical Commission.)

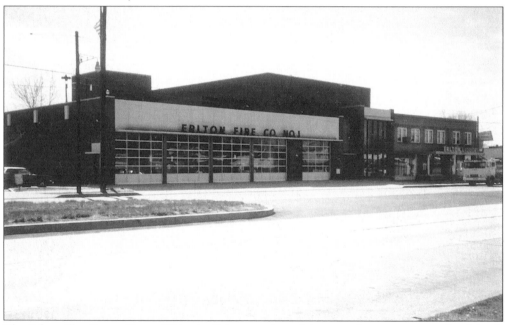

The Erlton Fire Co. on Route 70 in the Erlton section of the township was organized in March 1927 with 18 charter members. The seven independent fire companies were organized between 1914 and 1947. Each formed a fire district in 1957 to levy a municipal fire tax on residents. The companies merged in January 1994 to form one fire department that employs career and volunteer members. (Cherry Hill Public Library.)

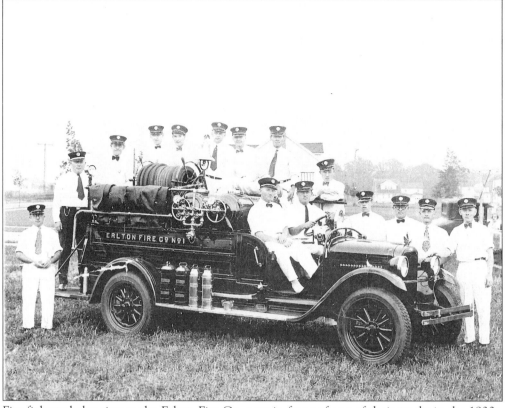

Fire fighters belonging to the Erlton Fire Co. pose in front of one of their trucks in the 1930s. (Cherry Hill Historical Commission.)

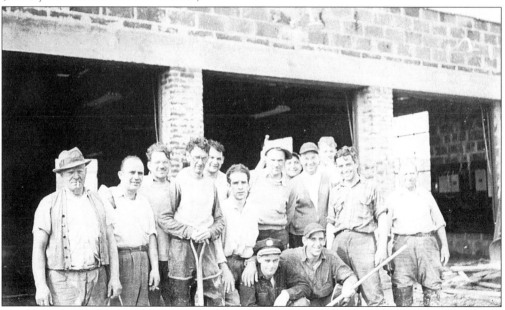

Members of the Woodland Fire Co. work on the construction of the firehouse on Beechwood Avenue in 1947. (Carol Genzano.)

In 1948 the company at the old Deer Park firehouse became the last fire company to organize in the township. (Cherry Hill Public Library.)

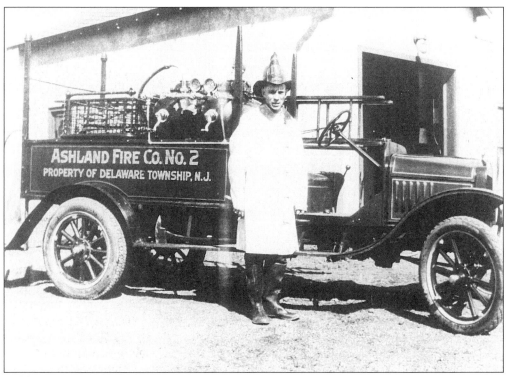

Ashland's first fire chief poses with the department's truck in the early 1910s. (Bob Georgio.)

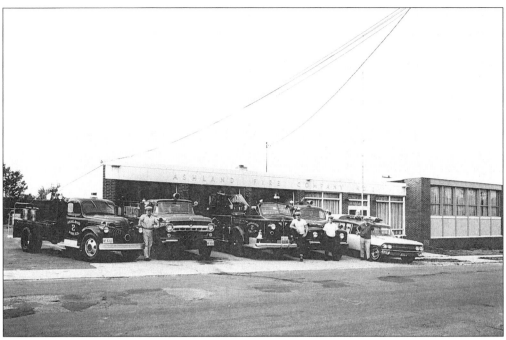

Members of the Ashland Fire Co. pose with pieces of their equipment in the 1960s. The building is now the Cherry Hill Fire Department's administration building. (Bob Georgio.)

Several members of the Ashland Fire Co. stand outside their clubhouse just off Burnt Mill Road in the 1950s. The hall was the focal point of socials, meetings, and gatherings in the Ashland community for years. (Bob Georgio.)

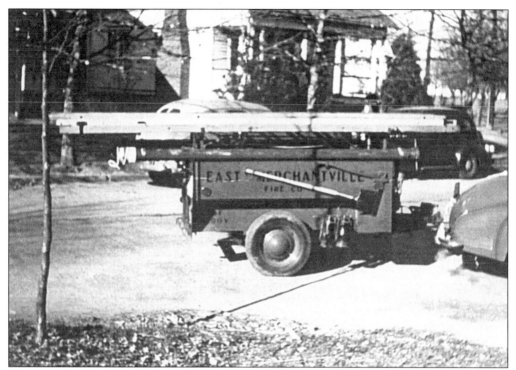

This was the East Merchantville Fire Co.'s first piece of equipment, a civil defense trailer hitched to a member's vehicle in case of a fire. (Dick Harley.)

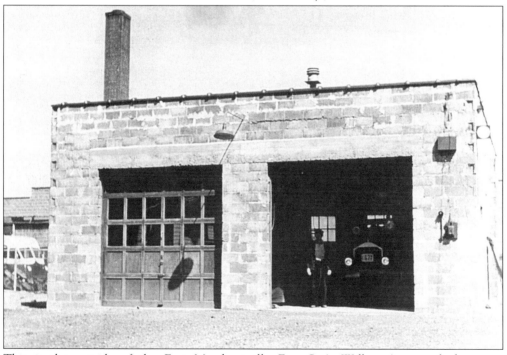

This is the outside of the East Merchantville Fire Co.'s Wilbur Avenue firehouse as construction concluded in 1946. (Dick Harley.)

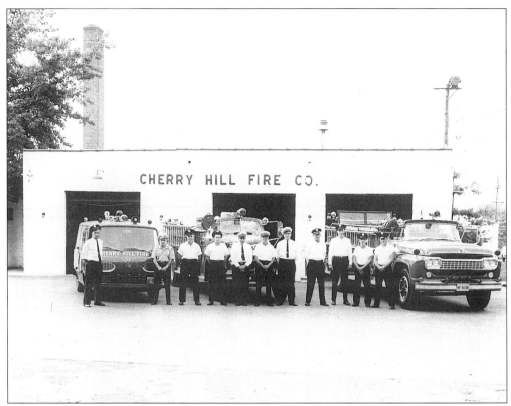

Members of the Cherry Hill Fire Co. pose in front of their firehouse on Wilbur Avenue on July 17, 1964. The company changed its name from East Merchantville to Cherry Hill No. 1 after the township changed its name from Delaware Township to Cherry Hill. (Dick Harley.)

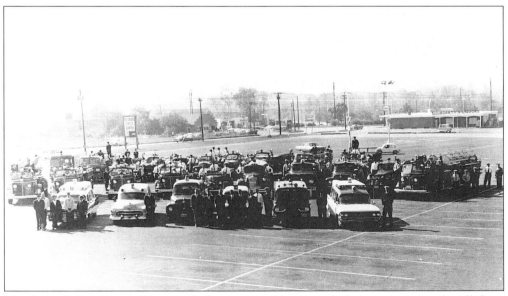

Members of all seven of Cherry Hill's fire companies pose with their apparatus at the Ellisburg Shopping Center in the 1960s. (Dick Harley.)

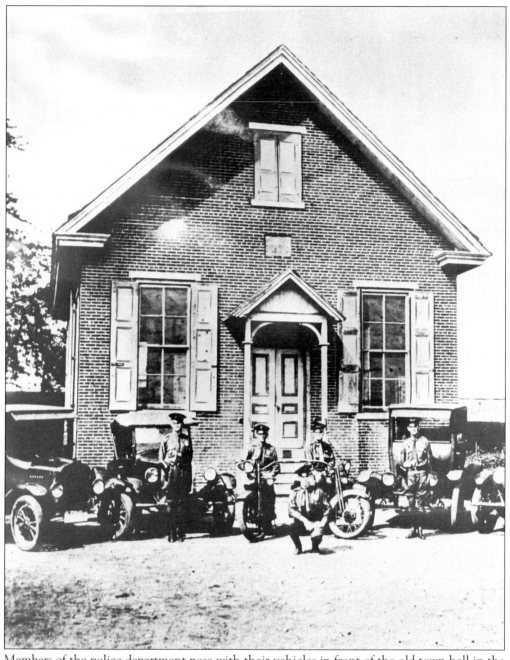

Members of the police department pose with their vehicles in front of the old town hall in the early 1920s. (Eva Gilmour.)

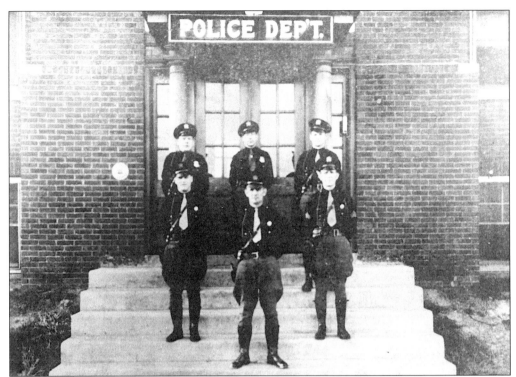

Members of the police department pose in front of the police department in the 1930s (above) and 1940s (below). (Bill Lattiere.)

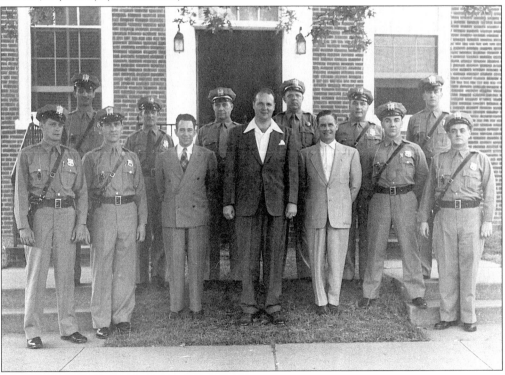

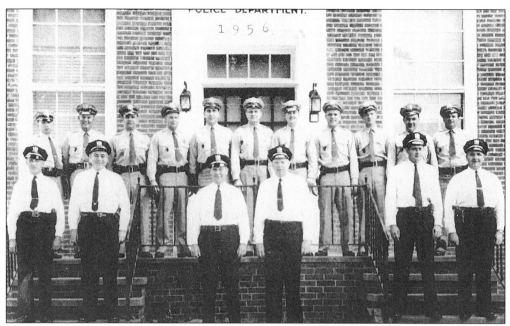

Delaware Township police officers pose in front of the police station in 1956. As the township grew, the number of officers needed to protect residents increased as well. By the late 1990s, the department had more than 127 sworn officers patrolling 24 square miles of land inhabited by just under 70,000 people. (Bill Lattiere.)

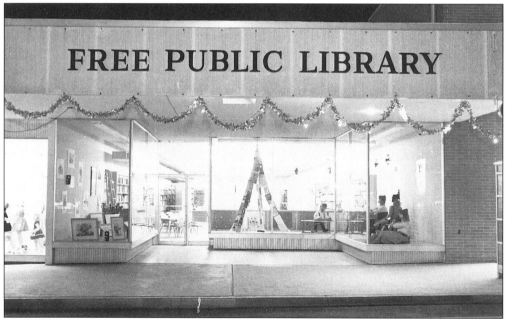

The Cherry Hill Free Public Library was located at the Ellisburg Shopping Center in the early 1960s. The library, which was established following a successful referendum in November 1960, was located first in the police station, then in the municipal building, and from October 1961 to October 1966 at the shopping center. By 1966, the library had a permanent home on Kings Highway. (Cherry Hill Public Library.)

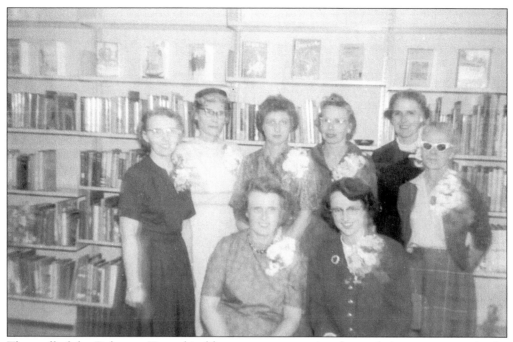

The staff of the Delaware Township library pose on opening day at their new quarters in the Ellisburg Shopping Center on October 10, 1961. (Cherry Hill Public Library.)

FORGET SOMETHING?

The string tied around your finger was to remind you to return the following overdue books drawn on your library card:

TITLE DUE

Delaware Township Public Library
Police Station, Route 70, Erlton, N.J.

This reminder was sent to patrons of the Delaware Township Library who failed to return their books on time. (Cherry Hill Public Library.)

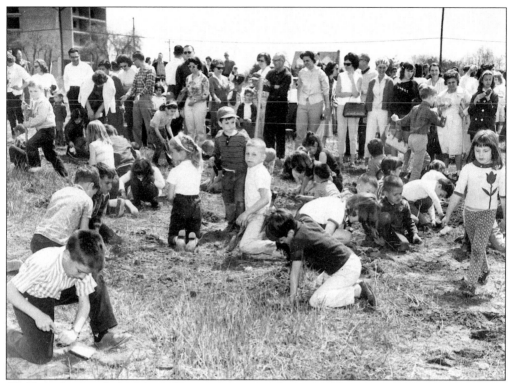

Children don small shovels as they participate in the ground-breaking ceremony for the new township library on Kings Highway in 1965. (Cherry Hill Public Library.)

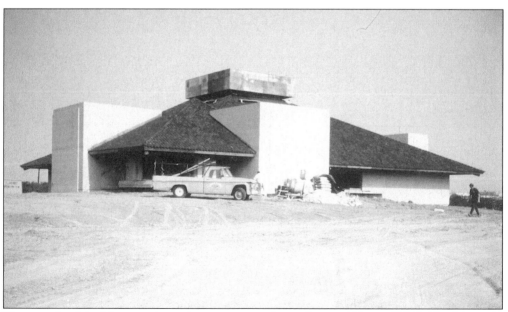

The outside of the library is shown here as it neared completion. (Cherry Hill Public Library.)

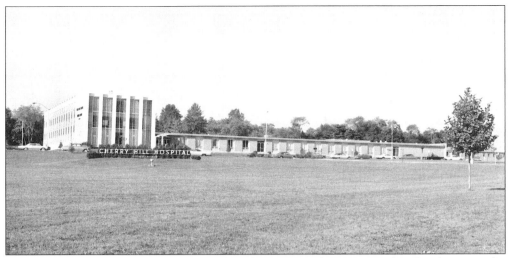

Cherry Hill Hospital opened in 1960 at Chapel Avenue and Cooper Landing Road to serve the large number of people moving into the township. Today the hospital is part of the Kennedy Health System. (Cherry Hill Historical Commission.)

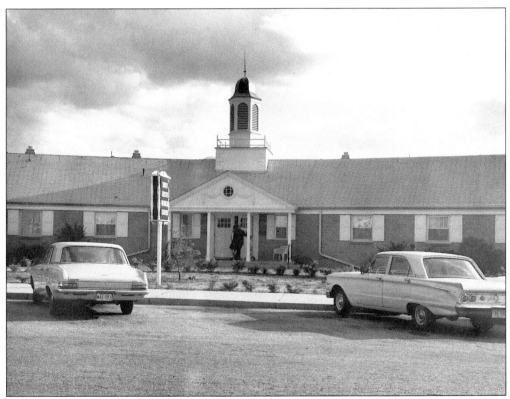

In addition to the Cherry Hill Hospital, the Cherry Hill Medical Center opened along Route 70 in the 1960s to serve area residents. (Cherry Hill Historical Commission.)

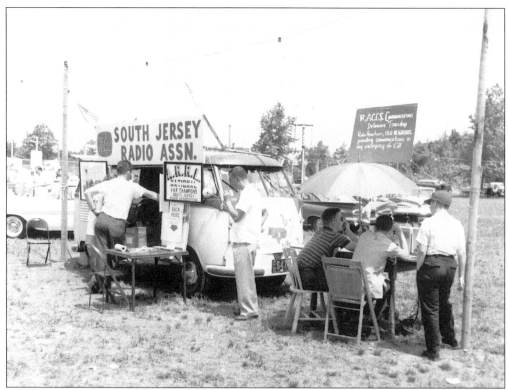

Members of the South Jersey Radio Club display their equipment at a Delaware Township Fair in the 1950s. (Cherry Hill Historical Commission.)

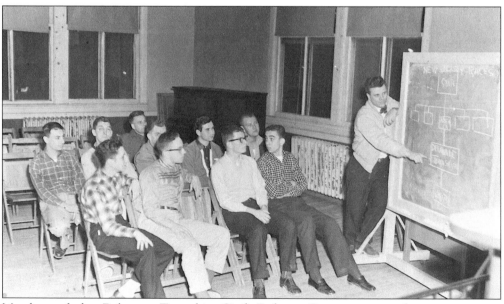

Members of the Delaware Township Civil Defense Corps meet to discuss emergency management strategy in the 1950s. (Cherry Hill Historical Commission.)

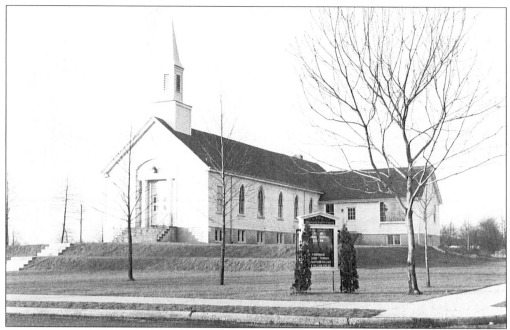

The Erlton Baptist Church is one of the township's oldest congregations, beginning its first ministry in 1833 under the auspices of the First Baptist Church of Haddonfield. Sunday school gatherings met in various farmhouses until the first chapel was built in the area of the Ellisburg Circle in 1885. The church moved to Connecticut and Pennsylvania Avenues in 1949. (Haddonfield Historical Society.)

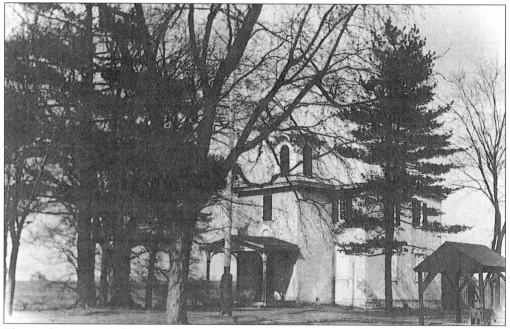

This is the original Ellisburg schoolhouse, built on land owned by Joseph Ellis in 1831 and demolished in 1914. A brick edifice was built in its place but was torn down in 1968. (Camden County Historical Commission.)

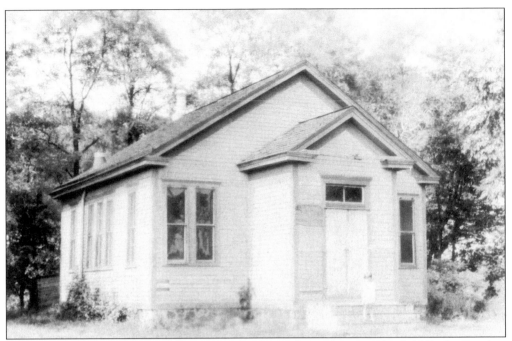

The Horner Hill School was a one-room schoolhouse located on Haddonfield-Berlin Road in the area now known as Downs Farm. The development was named for the farm operated by Thomas J. Downs. The school appeared on a 1877 Delaware Township map but ceased operation in 1925 when the Wesley Stafford School opened. The Horner Hill School was one of five one-room schoolhouses that existed in Delaware Township. (Eva Gilmour.)

The Hillman School on Kresson Road was a one-room schoolhouse that was used as a school for tenant farmers until it closed in 1925. The school opened sometime before 1840, almost 50 yards from the Hillman Chapel. (Cherry Hill Historical Commission.)

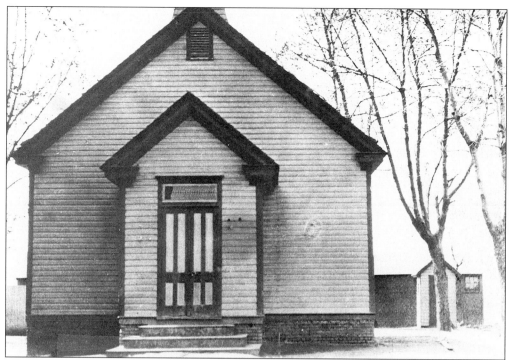

The Hinchman School opened as a one-room schoolhouse in September 1922, at Route 38 and Chapel Avenue, to alleviate overcrowding at the Ellisburg School. The school was built on land owned by farmer Joseph H. Hinchman, who owned a tract of 188.5 acres. When Route 38 was completed, Hinchman School formed the safety patrol in the township and the fourth in the state. An annex was constructed in 1962, but the school closed by the late 1970s due to decreasing enrollment and is now the Cherry Hill Convalescent Center. (Cherry Hill Historical Commission.)

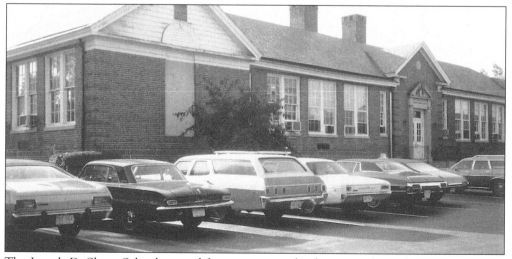

The Joseph D. Sharp School, named for a prominent landowner and member of the board of education, opened on Marlkress Road in 1928. It served as the district's administration building for a time, after a new Sharp School opened on Old Orchard Road in the Old Orchard section of the township. (Cherry Hill Public Library.)

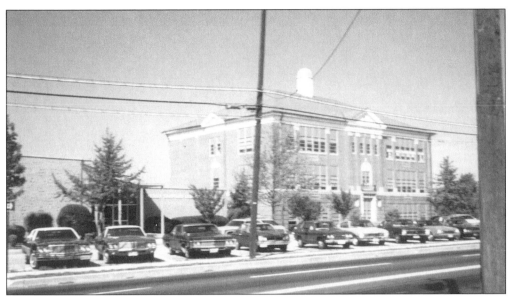

The Wesley R. Stafford School opened in the fall of 1925 on land along Haddonfield-Berlin Road, adjacent to the Brookfield development. It was known simply as School No. 3 during the first three years of its existence until it was named after Stafford, a longtime school district clerk. An addition was built in 1962, but the school closed in the late 1970s because of decreasing enrollment. Today the school houses the alternative program Brookfield Academy. (Cherry Hill Public Library.)

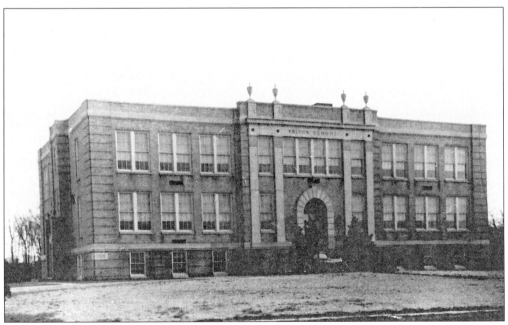

The Erlton School opened in 1928 and derived its name from Earl R. Lippincott, the man responsible for the housing development in the area, which was formerly known as Cooperstown. The school closed in the 1970s and was demolished in the early 1990s. (Cherry Hill Historical Commission.)

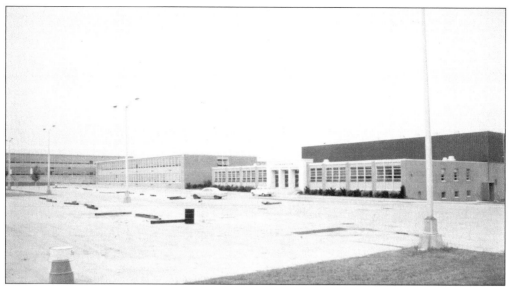

Cherry Hill High School West opened as Delaware Township High School in September 1956. Before its construction, the township's high school students paid tuition to attend classes at Haddonfield, Merchantville, and Pennsauken High Schools. The name of the high school was changed to Cherry Hill High School in 1962 when the name of the township became Delaware Township, and it was changed again when Cherry Hill High School East was constructed in 1966. (Cherry Hill Historical Commission.)

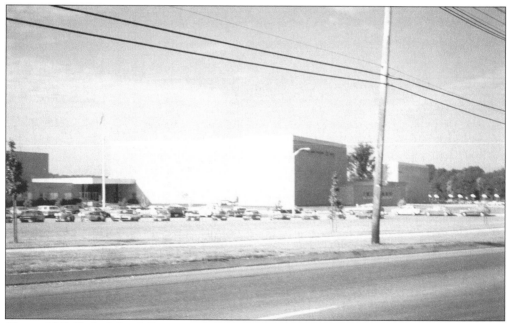

Cherry Hill High School East was constructed on Kresson Road in 1966 due to increasing enrollment at Cherry Hill High School and the growth of the township's east side. (Cherry Hill Historical Commission.)

The Cropwell Friends Meeting House was established in 1760 at Cropwell Road and Old Marlton Pike in neighboring Evesham. The present building was built in 1816. (Cherry Hill Public Library.)

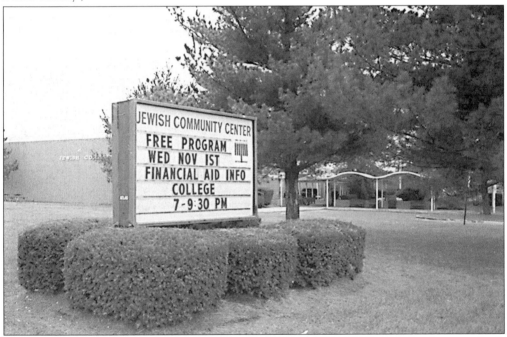

The Jewish Community Center was built in the mid-1950s on Route 70 near the township's border with Pennsauken, following the large Jewish population that had thrived for years in Camden. The community center relocated again in the 1990s to the corner of Springdale and Kresson Road. (Rachelle Omenson.)

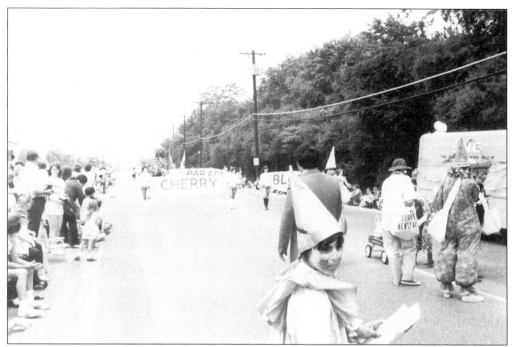

The Cherry Blossom parade, an annual event that began in 1972 among residents of the Knollwood development, was started to help build community pride. As part of the effort, resident Joe Zanghi began planting cherry trees along Chapel Avenue between Haddonfield Road and Kings Highway. The parade ended in 1992 but Zanghi continues to plant the trees. Since 1973, he and other volunteers have planted 1,269 cherry trees along the route. (Joe Zanghi.)

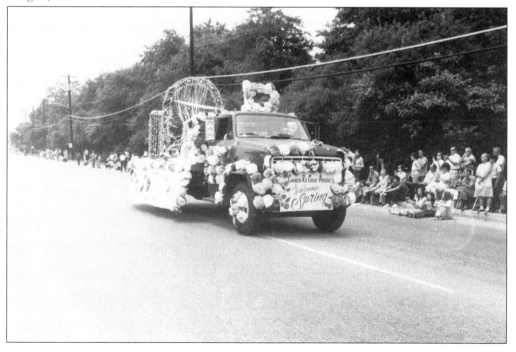

For decades, the people of Delaware Township and Cherry Hill have enjoyed a parade celebrating a holiday or event. Here, spectators watch a parade as it passes by the old town hall in the 1930s. (Lou Toth.)

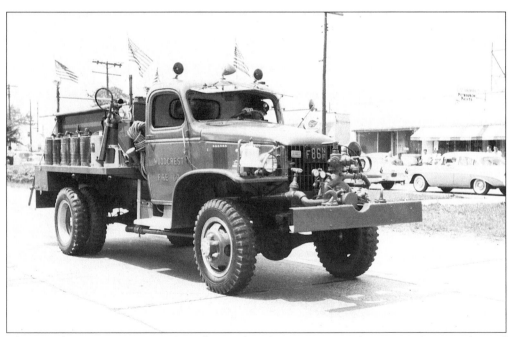

The Woodcrest Fire Company has always played a prominent role in township parades and other festivities. Here, spectators watch as a Woodcrest fire truck proceeds down Route 70 through the Erlton section during a parade in the 1950s. (Ron Judlicka.)